ART OF THE TIME

OREGON'S STATE CAPITOL ART COLLECTION

This catalog is published on the occasion of the reinstallation of the Oregon State Capitol Art Collection, January 2011. The reinstallation project was made possible by Oregon's Percent for Art in Public Places program, ORS 276.080, and facilitated by the Oregon Arts Commission. The Capitol Art Collection is owned by the Oregon State Capitol on behalf of the State of Oregon, and publicly accessible to all.

Contents

FIGURE 1.
Louis Bunce (1907–1983). *Midway #5*. 1975. Oil on canvas.
One of the paintings conserved during the reinstallation. Cleaned and re-stretched, *Midway #5* is now displayed prominently in the Capitol's State Street Entrance.

Foreward

Oregon, always a pioneer, was one of the first states in the nation to pass Percent for Art legislation. Since 1975, the Percent for Art program has maintained a commitment to the placement of permanent art of the highest quality in public buildings. Committees of local citizens across Oregon have helped build a collection of artwork that enhances the state's public spaces and contributes to our well-recognized quality of life.

The renovation of the State Capitol Wings, approved by the 75th Oregon Legislature, generated Percent for Art funds that provided the opportunity to assess, conserve and reinstall one of the most important assemblages of works of art in the State's holdings.

The reinstallation of Oregon's State Capitol Art Collection was a complex and lengthy undertaking, and like any project of this scale, involved many people and talents. We are thankful to the legislators, Senators Richard Devlin and Ted Ferrioli and Representative Arnie Roblan, who served on the art committee for the project and brought their experience and perspectives as stewards of the artwork. Judy Hall, secretary of the Oregon State Senate, and Ramona Kenady, chief clerk of the Oregon House of Representatives, offered their years of experience in the building as decisions about the collection were made.

Legislative Administrator Scott Burgess, Herb Colomb, former head of Facilities Services, and architect Kelley Howell ensured that the removal, appraisal and ultimate reinstallation of the 180 pieces of art meshed with the renovation of the wings and the use of the new and improved spaces by the members of the Legislative Assembly and the public. Frankie Bell of the Oregon State Capitol Foundation, historic preservationist Elisabeth Walton Potter and John Olbrantz of the Hallie Ford Museum of Art were generous with their expertise on Oregon's art history and the significance of the collection.

We owe considerable thanks to Larry Fong, curator of American and regional art at the University of Oregon's Jordan Schnitzer Museum of Art, for reinterpreting the collection and its significance and designing the plan for its reinstallation.

We thank Jennifer Stoots, who conducted a thorough appraisal of each work, and collaborated with Larry Fong on the writing of the essay on the Capitol's collection of photographs, an important visual record of the state. Art historian Prudence Roberts researched and wrote the biographies now installed on information labels throughout the building, and included in this catalog. Her work provides meaningful insight into each artist and work.

Special thanks goes to Meagan Atiyeh, visual arts coordinator of the Arts Commission, who managed the overall project and authored the essay chronicling the process of building the collection, first called "Art of the Time."

The Oregon Arts Commission assists many public agencies with the selection of art to enhance our shared public spaces. Particularly in these challenging times, it is important to care for and protect Oregon's cultural treasures so they are appreciated and shared by future generations. There is no more public space than the Oregon State Capitol, and the reinstalled collection will be appreciated by many.

To the artists of Oregon whose work forms this significant collection and to many more who live and work here, thank you.

Christine D'Arcy, Executive Director
Oregon Arts Commission – Oregon Cultural Trust

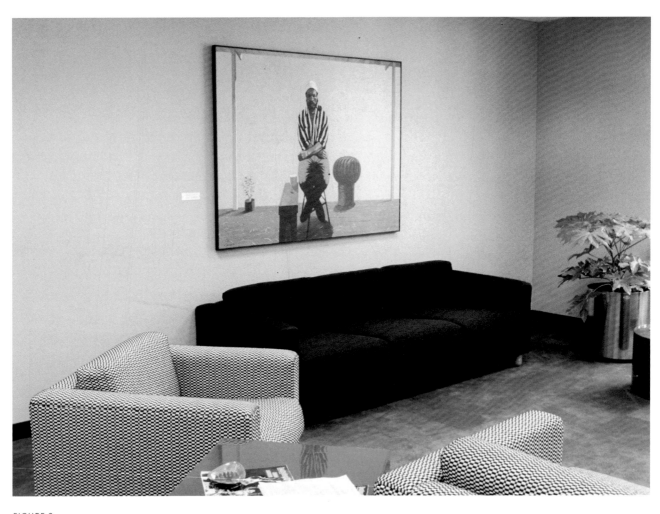

FIGURE 2.
The original interiors of the new Capitol Wings, designed by architects Wolf, Zimmer, Gunsul and Frasca. Shown: George Johanson's 1977 portrait of his friend and colleague, artist Manuel Izquierdo (1925–2009).

The Capitol Art Collection:
Three Decades Later

Meagan Atiyeh

In 1975, the Oregon State Capitol began plans for a major expansion which would provide legislators with offices for the first time (until then, they worked from desks on the chamber floors). The new Capitol Wings, designed by Portland architects Wolff, Zimmer, Gunsul and Frasca (now Zimmer, Gunsul, Frasca) would double the square footage of the Capitol and create new spaces in which the public could visit their representatives.

Anticipating the construction project, and with leadership from the Oregon Arts Commission, the Oregon Legislature enacted Oregon's Art in Public Places program that year. One of the first such state programs in the country, the law recognized the talented artists and craftspeople of Oregon and beyond, and set aside "not less than one percent" of the construction dollars allocated for state building for the purpose of commissioning and acquiring artwork. The initial legislation applied only to Salem's Capitol Mall area. In 1977, the statute was extended to cover all state buildings.

The construction of the Capitol Wings triggered Oregon's first Percent for Art project. The project was guided by a selection jury,[1] which was in turn assisted by a screening committee of prestigious members of the arts community, who recommended works of art for acquisition.[2] The work of these groups, with input from a Legislative Advisory Committee, led to the purchase and commission of 170 works of art for the Capitol between the years 1976 and 1978.[3]

A Collection of its Time

Art collections are driven by a number of factors, including period, style, taste and investment potential. Private collectors and smaller museums often focus on a particular medium, or a specific artist or style. Major institutions grow their collections over decades, paying close attention to their institutional charter and to expanding and deepening their existing holdings.

The State Capitol Collection selection jury stated its intent to purchase "artworks that were and would remain significant to Oregon's history." They laid down no predetermined criteria with regard to aesthetic or content. Paintings, prints and drawings were considered alongside textiles, ceramics and sculptural works in all media. A distinct collection of photography, from the late nineteenth century onward, represented the only prescriptive component of the undertaking. The building of this collection, which was titled Oregon in the 20th Century, is discussed in the essay "A Collection of Photography."

The jury for the larger collection crafted a public process for the selection of work that included open calls to Oregon artists, nominations and gallery and studio visits across the state by committee members. The process took most of two years, and resulted in a collection of art of the time, made by artists born over seven decades, from established masters to emerging talents. Aside from the photography collection, the works chosen were predominantly created in the years 1976 through 1978. As such, the Capitol

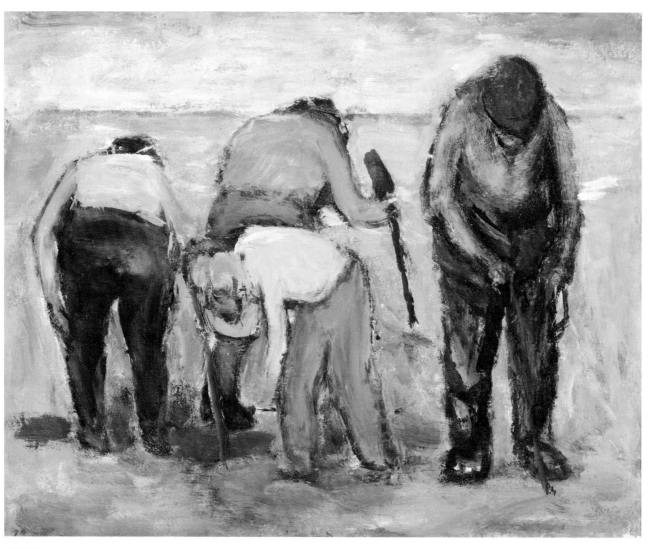

FIGURE 3.

Arthur Runquist (1891–1971). *Oregon Clam Diggers*. n.d. Oil on panel.
One of the many works in the Collection documenting the Oregon coast, in this case likely Neakahnie. According to art historian Roger Hull, brothers Arthur and Albert Runquist, and contemporary Charles Heaney, often reworked one painting over a number of years, making date attribution difficult.

Collection has a rare depth, and presents an unequaled opportunity to view Oregon's artistic landscape in detail at this particular historical moment.

By the late 1970s, the Northwest art world had received substantial international attention, much of it centered in and around Seattle. In the preceding four decades, "Northwest School" artists Morris Graves (1910–2001), Mark Tobey (1890–1976), Kenneth Callahan (1905–1986), Guy Anderson (1906–1988) and others had been included in major exhibitions and solo retrospectives at the Museum of Modern Art, the Whitney Museum of American Art and the Metropolitan Museum of Art, New York. In 1953, *Life* Magazine published a six-page feature article on the four artists under the title "The Mystic Painters of the Northwest." In 1958, Mark Tobey received the Painting Prize at the Venice Biennale, the first American to do so since James Abbott McNeill Whistler (1834–1903). In 1978, two years after Mark Tobey's death, the Seattle Art Museum exhibited the work of seventeen artists who had come to define the most productive and renowned period of Pacific Northwest art. The exhibition and catalogue bore the title "Northwest Traditions,"[4] and signaled a regional willingness to close a chapter of our Northwest history, if not to embrace a definition of regionalism.

While the Northwest School had emerged from a relatively small community of influence, many of the artists included in the Seattle exhibition were formed by broader experiences and locales. They had studied in New York and Chicago, Los Angeles, Paris and Japan. Many of them traveled broadly. Three of the artists were living and working in Portland in 1978: Louis Bunce (1907–1983), Hilda Morris (1911–1991), and Carl Morris (1911–1993). The exhibition also included the Oregon painter C.S. Price (1874–1950), whose influence remains considerable throughout the region to this day.[5] It is from this setting—a retrospective sensibility of a Northwest arts community proud of its successes, having a relatively short but fertile art history to draw from, a region informed both by those raised here and new arrivals—that a group of arts professionals was tasked with building a State Capitol Art Collection to represent Oregon.

Only two of the artists collected (aside from the photography project) were not alive in 1978: brothers Albert (1894–1971) and Arthur Runquist (1891–1971). Their inclusion, however, along with contemporaries Charles Heaney (1897–1981), David McCosh (1903–1981), William Givler (1908–2000), and Louis Bunce (1907–1983), reflects the committee's knowledge and respect for the history of Oregon art, and serves as a starting point for the remainder of the collection.

Among the most recognized Oregon artists of their time, Albert and Arthur Runquist and Charles Heaney shared a deep connection to place. For the Runquists, this was the Oregon coast, where they lived and painted. Charles Heaney, when not painting the humble architecture near his North Portland home, was drawn to the broad horizons of central and eastern Oregon, and frequently returned to his favorite views. Each of these artists had been engaged in creating works for the WPA, and were linked by subject matter and technique to Depression-era social realism and early modernist approaches. The three artists were also highly influenced by their Northwest predecessors. Each studied under Harry Wentz (1875–1965) at Portland's Museum Art School (and it was in Wentz's studio at Neakahnie that the Runquist brothers lived for many decades). Heaney was largely influenced, both in style and professional practice, by a friendship with the great C.S. Price (1874–1950), twenty-three years his senior.[6]

After graduating from the Art Institute of Chicago in 1926, David McCosh traveled and painted for two years in Europe, before returning to begin his teaching career at his alma mater. In 1934, McCosh accepted a position at the University of Oregon, where he continued to teach until 1970. He arrived in the region with an established interest in the figure, but the Northwest landscape had a profound effect on him, as it had on Heaney and the Runquist brothers. The University's Jordan Schnitzer Museum of Art, which houses his collection and mounted solo exhibitions for McCosh in 1958, 1963, 1967 and 1977, characterizes this shift as follows: "Responding to the lush environment quite unlike what he was accustomed to in Iowa, McCosh allowed his Midwest regionalism to fall away. Gradually, he adjusted his painting practices to include a greater interest in an observation of nature that would become the dominant focus of his work for the remainder of his painting career."[7]

At the time of the Capitol renovation, friends and colleagues Louis Bunce and William Givler had been retired for five years after long careers at the Museum Art School (now the Pacific Northwest College of Art), where they originally met as students in the 1920s, before moving together to New York to study at the Art Students League. On their return to Portland, Givler founded the Museum Art School's printmaking department, and Bunce had a prolific teaching and painting career in Portland and New York. His work was included in major exhibitions at the Metropolitan Museum of Art, the Museum of Modern Art and the Whitney Museum of American Art. Bunce also maintained a friendship with fellow Art Students League student Jackson Pollock.[8]

Oregon enjoyed strong ties to the international art world in the 1970s, led by artists—such as Bunce and Givler—who had studied in New York and, after their return to Oregon, maintained an interest in the city as the epicenter for sculpture and painting it had become after World War II with the develop-

ment of abstract expressionism, color field, and pop art. Furthermore, a number of established Oregon artists of the 1970s had developed their talents on the East coast or in Europe and South America before moving to the Northwest, among them Sally Haley (1908–2007), Michele Russo (1909–2004), Hilda Morris (1911–1991), Carl Morris (1911–1993) and Jan Zach (1914–1986).

Sally Haley had moved to Portland in 1947 with her husband, artist Michele Russo. Both Russo and Haley trained at Yale University. Russo taught at the Museum Art School during the tenures of Bunce and Givler, and had been retired for four years in 1978. (Russo served on the Capitol Collection's screening committee, and is not represented in the collection.) In 1975, Haley received a major retrospective at the Portland Art Museum, and her work had been exhibited and collected widely throughout the Northwest. Haley's still-life paintings, rigorously modern and spare compositions, feature items of domestic life against clean geometric field and form (Figure 4). Despite the fact that Haley's work had not received national attention, it reflected traditions and influences of the national art world. Long-time dealer Arlene Schnitzer commented that Haley was "wholly uninfluenced by the region."[9]

A contemporary of Haley and Russo, sculptor Hilda Morris was born Hilda Deutsch in New York and studied at the Art Students League and Cooper Union. The WPA brought Morris to the Northwest to teach at the Spokane Art Center, where she met and married Carl Morris, and the couple moved to Portland in the late 1940s. While they would both be associated with the Northwest School, Hilda Morris' work, intellectually inspired by music, metaphor, and mythology, is as much influenced by her studies in New York, and by abstract expressionism there and throughout Europe. Morris was included in exhibitions at the Metropolitan Museum of Art, the Brooklyn Museum and New York galleries. In 1978, Morris was dividing her time between Oregon and Pietrasanta, Italy, where she maintained a studio.[10]

Although born in Albany, Oregon, Gordon Gilkey (1912–2000) was a significant force in exposing the region to European art and artists. After receiving the first ever Master of Fine Arts from the University of Oregon in 1936, Gilkey, a master printmaker, was appointed official etcher for the New York World's Fair in 1939, during which time he also studied at the Art Students League. From 1939 to 1947, Gilkey served the United States military as co-founder of the US Commission for the Protection and Salvage of Artistic and Historic Monuments in War Areas, and as chief of the US War Department Special Staff Art Projects in Europe, where he oversaw the recovery and return of works of art stolen by the Nazis. Gilkey developed relationships with European artists of the time, including Max Beckmann, and would continue to celebrate and promote the work of European artists after his return to Oregon, where in 1947 he became chairman of the art department at Oregon State College (later Oregon State University), and later dean of the School of Humanities and Social Sciences. In 1977, Gilkey retired from OSU and became curator of prints and drawings at the Portland Art Museum, where he built a collection of over 25,000 works on paper.

In 1978, Czechoslovakian-born and trained sculptor Jan Zach (1914–1986) was in his final years of a two-decade career on the faculty at the University of Oregon's School of Architecture and Allied Arts. Zach's list of exhibitions and commissions stretches from his native Prague to New York, where he decorated the Czech Pavilion for the 1939 World's Fair; then to Brazil (he would not return to Prague, which was then occupied by the Nazis), where he exhibited and taught throughout the 1940s. There he met and married Judith Monk, and they moved in 1950 to her native Victoria, British Columbia. While Zach worked in printmaking and scenic design over his career, the bulk of his work was sculptural, utilizing both metal and wood, as in *Drapery of Memory*.[11] Art historian Roger Hull describes the underlying psychological attitude of Zach's sculptures as a celebration of courage and freedom in the face of oppression.[12]

Two younger artists in exile similarly brought deep political wounds with them to Oregon: Manuel Izquierdo (1925–2009) and Henk Pander (b. 1937). Izquierdo was a child when the Spanish Civil War scattered his family to refugee camps in France, and ultimately, through the American Friends Service,

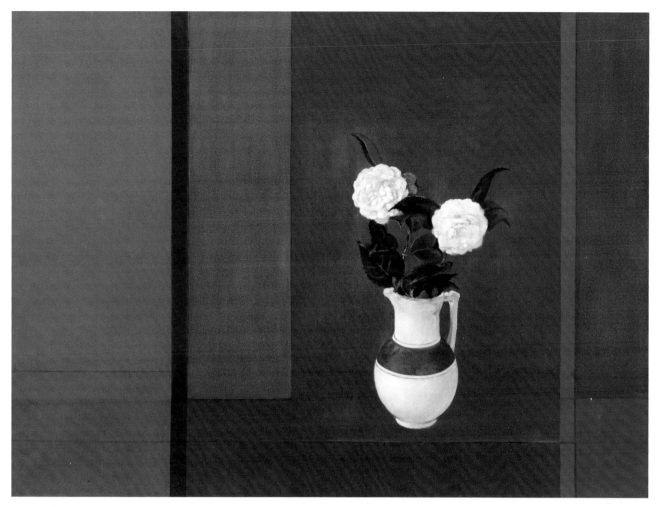

FIGURE 4.
Sally Haley (1908-2007). *Camellias*. n.d. Acrylic on canvas.
Curator and art historian Prudence Roberts writes, "*Camellias* has a quiet certitude, reminiscent of artists like Jan Vermeer, where simple objects attain a majestic beauty."

to Portland. Izquierdo studied with Louis Bunce and Jack McLarty (b. 1919) at the Museum Art School; he graduated in 1951 and taught there for the next 46 years. Izquierdo's biomorphic sculptural works express the pathos and celebration of his history. As a printmaker, Izquierdo explored a number of fantastic realities, such as rodeos, circuses and his escape from Spain as a young man. By 1978, the artist was nearly three decades into his long teaching career and a fixture in the regional art world. He had received two solo exhibitions at the Portland Art Museum.[13]

Henk Pander, having fallen in love with an Oregonian in The Netherlands, came to Portland by choice, bringing with him his experiences as a young man in a Nazi-occupied Europe. In Portland, Pander taught briefly at the Museum Art School, from 1965 to 1967. Working in multiple themes throughout his career, Pander has maintained a preoccupation with war and oppression in a portion of his artistic output. By the late seventies, his work had been exhibited widely throughout the region, including a solo exhibition at the Portland Art Museum. He was also active in a theater and artistic scene centered around the alternative Storefront Theater, which he co-founded, and often illustrated posters for local bands and political causes.[14]

A fellow faculty member and close friend of Manuel Izquierdo was George Johanson (b. 1928), who also studied with Bunce, Givler and McLarty. These mentors encouraged the young Johanson to spend

three years of study in New York.[15] In the late seventies, Johanson, like many of his contemporaries and predecessors, was dividing his time between painting and printmaking. He received his third solo exhibition at the Portland Art Museum in 1976. Johanson would go on to create a significant body of portraiture of friends and fellow artists, exemplified by his portrait of Manuel Izquierdo in the Capitol Collection (Figure 2).

Also teaching at the Museum School in 1978 were Harry Widman (b. 1929) and fellow graduates Jay Backstrand (b. 1934), Bonnie Allen (b. 1937), and Lucinda Parker (b. 1942). Widman served as Acting Director from 1978 to 1981, and was a member of the task force established to lead efforts for the state's Percent for Art Program. Parker (Figure 16), who joined the faculty in 1972, was enjoying a booming career. From 1976 to 1978, her work was included in exhibitions such as "Aesthetics of Graffiti" at the San Francisco Museum of Art, the "First Western States Biennial" (organized by the Western States Arts Federation), and at home in Portland at Reed College, the Portland Center for the Visual Arts, and the

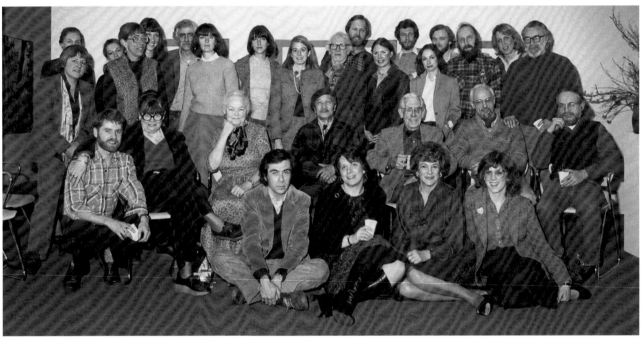

FIGURE 5.
1980 artists' luncheon at the Fountain Gallery. *Standing:* Mary Beebe, Susan Hall, Sybil Heidel, Lucinda Parker, Sherrie Wolf, Lee Kelly, Carolyn Cole, Marlene Bauer, Wendy Wells, Michele Russo, Scott Sonniksen, Anne Courts, John Jerard, Linda Hodges, Jim Minden, Richard Muller, Judith Poxson Fawkes, George Johanson; *seated:* René Rickabaugh, La Verne Krause, Sally Haley, Kenyu Moriyasu, Louis Bunce, Harry Widman, Manuel Izquierdo; *seated on floor:* Tom Fawkes, Laura Russo, Arlene Schnitzer, Serena Callahan. Photo courtesy Arlene Schnitzer/Fountain Gallery.

FIGURE 6.
A group exhibition, circa 1978, at the Fountain Gallery's Northwest 21st Avenue location, including works by, *back wall:* Jack Portland, Lucinda Parker, Sally Haley and Michele Russo; *left wall:* Carl Morris; *glass work in foreground:* Fred Heidel. Photo courtesy Arlene Schnitzer/ Fountain Gallery.

1977 and 1978 "Artists of Oregon" shows at the Portland Art Museum. The then thirty-five year old Parker's brand of vibrant abstract expressionism combined with cubist influences embodied her intensive study of art history (first at the Museum Art School and then at Pratt Institute in New York). Parker's dedication to this tradition, as she continued to refine her individual artistic voice, would make her one of the most respected painters of the region.

In 1970s Portland, a nurturing—and demanding—familial atmosphere had formed around two generations of relationships at the Museum Art School, giving rise to a broader constellation of galleries and artist-run exhibition spaces, including the Image Gallery, opened in 1961 by Barbara and Jack McLarty, and the Fountain Gallery, founded the same year by Arlene Schnitzer, then a student at the Art School. The Fountain Gallery would become a key platform for developing the careers of Northwest artists and a collecting base to support their work. It became the region's most influential commercial gallery for the next twenty-five years (Figure 5, 6).

The Fountain represented the work of many of the Northwest's most prominent and promising artists, a number of whom used the vast capacity of the gallery for storage of their work. Early in the morning of February 7, 1977, an arson fire, started in the alley of a restaurant below the gallery, destroyed the entire building. Many artists lost entire portions of their life's work.[16] Michele Russo, when asked to speak about the fire during a 1983 interview said, "There's no way of getting over it; that was just an enormous disaster, and it was a very shocking disaster. It left a kind of a big hole in your own personal history. I probably lost the equivalent of five or six years' work in the Fountain Gallery fire."[17] Governor Bob Straub issued a statement in response to the community's loss:

The fire that consumed the irreplaceable artwork at the Fountain Gallery of Art in Portland is a major tragedy. It is a personal tragedy for the many Pacific Northwest artists whose artwork was destroyed and a community tragedy for Oregonians throughout the State whose lives would have been enriched by this art. ... We have lost this artwork, but we have not lost the creativity that produced this art. All Oregonians can be proud of the significant advances we have made in the appreciation and promotion of art in our State. We must work to continue that progress.[18]

Eleven of the works destroyed in the fire had been selected for purchase for the Capitol, including paintings by Sally Haley, Tom Fawkes (b. 1941), Michael Dailey (1938–2009), and Lucinda Parker. In early March 1977, the Screening Committee met at the new Fountain Gallery (at 117 NW 21st Avenue) to view alternate works by the artists previously selected.

At that time, the relatively new Portland Center for the Visual Arts (PCVA) was actively connecting Portland with contemporary artists of national significance. Formed in 1971 by Jay Backstrand, Michele Russo, and Mel Katz (b. 1932), PCVA's exhibition list between 1976 and 1978 included now-famous artists working in New York, London, and Los Angeles: David Hockney, Robert Irwin, Brenda Miller and Alice Aycock, John Baldessari, Nam June Paik, Chuck Close, Richard Serra, Dan Flavin and Robert Morris. Local artists Louis Bunce and Michele Russo received solo exhibitions, and in 1976 renowned critic, curator and activist Lucy Lippard curated a group show of Northwest work: "In Touch: Nature, Ritual and Sensuous Art."[19]

PCVA also played a role in the selection of the Capitol Collection, accepting over 4,000 slides in response to an open call to artists issued by the Arts Commission in 1976. Screening committee members met at PCVA more than once to review the submissions, which were planned to be kept at PCVA as a slide registry for future reference.

A few years after PCVA's emergence, five young photographers formed The Oregon Center for the Photographic Arts (now Blue Sky Gallery) in 1975: Terry Toedtemeier (1947–2008), Christopher

Rauschenberg (b. 1951), Craig Hickman (b. 1948), Robert Di Franco (1950) and Ann Hughes (b. 1948). The gallery, in the same building as PCVA at NW 5th and Davis, was run as a cooperative, showing some of the best new local photographic talents.

Multiple Considerations

In the early meetings of the selection process, a number of possible locations in the Capitol were identified for major sculptural commissions: the west courtyard, the second floor terrace, and the State Street entrance.[20] Textile artist Judith Fawkes (b. 1941) was commissioned to create a site-specific tapestry. Her untitled eight-panel tapestry was designed specifically to hang in Hearing Room C, along the main corridor on the ground floor. Three artists were invited to create proposals for the west courtyard: Betty Feves, Ray Grimm (b. 1924), and Harry Widman. Upon review, however, the committee felt that the site presented too many difficulties for a successful artwork, and voted instead to consider the three artists for other purchases.

Five artists were invited to develop proposals for the State Street entrance: Manuel Izquierdo, Thomas Morandi (b. 1943), Hilda Morris, Bruce West (b. 1939), and Jan Zach. Tom Morandi, then a professor of art at Eastern Oregon State College (now Eastern Oregon University), was selected to create a major bronze sculpture, *November Sprinter* (Figure 7).[21] His design was an abstract work intended to visually soften the linear lines of the building's primary entrance. When the artist's models were unveiled to legislators and the public, there was some controversy surrounding the selection. Reporting on the Morandi commission for *The Oregonian*, Roger Hull wrote, "... his piece would establish a human scale and a human mood in the passage from the busy street." To those who had feared the work would be too abstract, Hull retorted, "The Capitol fully honors our pioneer heritage with the art it has in place right now. The fact that these days the state is a pacesetter in problem solving for the future is a reality that also needs expression in the Capitol's art. If it can be agreed by most of us concerned that such a piece as Morandi's expresses the flair and the energy the state is known for everywhere, Oregon with its one percent provision can look forward to a public art collection that will be exciting and strong."[22]

Missing Pieces

The task with which the committees for the Capitol Collection were charged—to purchase work of the time that would remain relevant for decades to come—was a difficult one. In a detailed assessment of the review process, Rachael Griffin of the screening committee wrote to Arts Commission director Peter Hero, "Naturally, we don't yet know how well our choices will 'wear' or how they will be received by the people who work in the building or the citizens who visit it. But I think our choices are solid." A further excerpt from Griffin's report helps characterize the sense of urgency and excitement for the task at hand:

> From the first it was a practical committee not spending much time philosophizing. It had its instructions to enrich the building with art of a high quality by Northwest artists and it had quite a bit of money to spend. Its members rejoiced that this would go to the deserving painters, sculptors and craftsmen of Oregon. They were ready to go to work.

> There weren't many spirited disagreements but there were one or two differences of approach which made their appearance sometimes, but which dissolved—perforce as it turned out—long before the committee had finished its assignment. Some members felt at first that we should be thinking about major works, commissioned—or anyway considered—for specific places in the building. The Morandi sculpture and

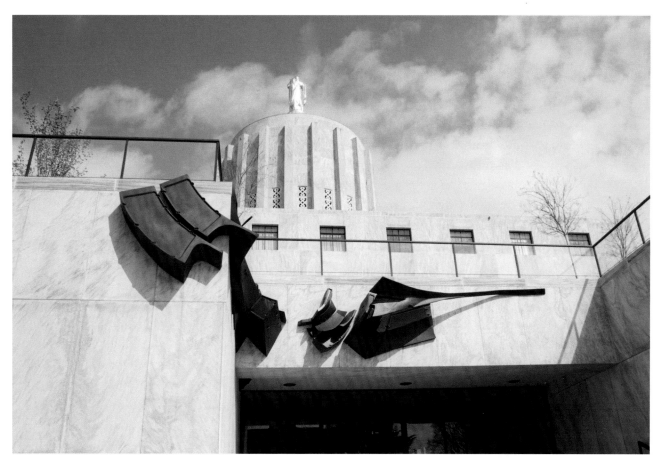

FIGURE 7.
Tom Morandi. *November Sprinter.* 1976. Bronze.
November Sprinter, one of two works commissioned specifically for the Capitol, took a year to complete.

the Judy Fawkes woven hangings are the surviving examples of this position. Others on the committee, especially artists, felt that this was pretty much a waste of time since there was a lot of good work all ready for us out there and that we should start buying it.

So we slipped into the relatively "easy" way (the only way, as it turned out) namely, of purchasing a lot of work and then hiring a competent designer-installer to arrange it in the building. Actually, our task wasn't *that* easy; many, many hours were spent in arrangements to see a maximum number of works from all parts of the state in all media—and on the final decision making.

Indeed, the committee had made many viewing trips, including visits to Gallery West, the Fountain Gallery, the Sunbow Gallery, and the Oregon State Fair (where the Louis Bunce painting was selected). After reviewing submissions at PCVA, the committee invited artists to bring work to two locations for day-long viewing: Reed College (December 17, 1976) and the University of Oregon Art Museum (January 13, 1977). Jan Zach's sculpture was viewed at his studio in Eugene and selected.

Throughout the selection, there were artists mentioned—according to the minutes of the committee's meetings, including notes made in the margins—who were never included in the collection. These included artists of the time and also established figures. One handwritten note by a screening committee

member reads: "Dead Classics: C. S. Price. Mark Tobey, Albert Runquist, Arthur Runquist, Jack Wilkinson / Live but Classics: Morris Graves, Ken Callahan, and / NY: Paul Georges, Ken Snelson, Una Wilkinson, James McGarrell, Milton Wilson."

While there are no other notes of further attempts to pursue works by these important regional figures, it may be assumed that the screening committee felt a more pressing need to support the community at hand than to present a collection of classics—to truly represent the art of their time, while recognizing, as far as they were able, those who had exerted influence through their teaching and inspiration. It is quite likely that, pressed to expend their funding and to install a collection, the committee was also limited by market availability. The Capitol Collection is certainly far from a biennial-type survey of the newest voices. The youngest of the artists had largely received at least regional exposure. However, it remains a collection of works by artists who, much to the committee's credit, had many accomplishments ahead of them.

A Collection Revisited

In 2008, the Capitol Wings underwent a major renovation. The art collection was placed in storage, and a selection committee was formed to address the roughly $180,000 of qualifying Percent for Art funds that would become available.[23] Recognizing the art collection as valuable resource for the citizens of Oregon, the committee members set as a priority the care, assessment, conservation and reinstallation of the works. At their instigation, appraiser Jennifer Stoots was contracted to review the condition of the works in the collection, consult with qualified conservators on necessary cleaning and repairs, and complete a full appraisal of the works.[24]

Lawrence Fong, curator of American and regional art at the Jordan Schnitzer Museum of Art, was contracted to design the reinstallation, in consultation with the committee. In his design, Fong created thematic groupings, placing works together that inform one another stylistically or in terms of content. Perhaps the most significant decision was to integrate the photography collection, previously installed separately, into the overall collection of prints, paintings and sculptures. In order to gather more background information on the Collection and its significance, art historian and curator Prudence Roberts, professor at Portland Community College and former curator of American art at the Portland Art Museum, was engaged to research and develop biographical information for each of the artists and works.

The art selection committee's most spirited conversations revolved around the integrity of the collection as a whole. The intervening three decades had provided a new historical lens through which to consider the works, and some of them now appeared less relevant to the collection as a whole. There were also examples of works by now-master artists that represented relatively minor aspects of that artist's career, rather than being iconic representations of his or her artistic legacy. One such case is Terry Toedtemeier's 1975 photograph *Newspaper*. An example of Toedtemeier's early experiments with infrared photography, the photograph is compelling and even humorous, but it represents an obscure element of the artist's life work, in which his well-known landscapes of the Pacific Northwest occupy the most prominent place. However, *Newspaper* is representative of the work Toedtemeier was producing in 1975, and it further documents the cultural circumstances of Portland in the late 1970s, especially when viewed alongside the works of Rauschenberg, Hickman and Di Franco, who, along with Toedtemeier and Ann Hughes, came together to found Blue Sky Gallery. After in-depth discussions, the committee felt that the collection, as originally selected, should be respected as an historical whole and remain intact. Only four works, which were found to be irreparable or for which repairs would far exceed the value of the piece, were recommended to the Oregon Arts Commission Public Art Advisory Committee for deaccessioning.

In refusing the role of revisionist, the 21st-century committee had made a key decision that would also serve to inform its search for new acquisitions. The renovation of the wings had in fact reduced

FIGURE 8.
James Lavadour. *Flag 2*. 2001. Oil on panel.
One of fourteen new acquisitions to the collection, *Flag 2* was purchased for the Capitol with funds provided by The Ford Family Foundation's Visual Arts Program.

the total available wall space, resulting in limited opportunities for new purchases. Nevertheless, it was felt that adding to the collection would constitute an important extension of its legacy, one that could serve to deepen the historical record and acknowledge more contemporary Oregon artists. Under the guidance of the Arts Commission and advisors Larry Fong and Jennifer Stoots, the committee considered new purchases based on priorities similar to those of the original committee, including the artist's stature in the history of Oregon, as well as artistic and geographic diversity in representing the state.

A total of fourteen new acquisitions were made. Four works were chosen for the photography collection, with the goal of completing Oregon in the 20th Century through additions of contemporary works from the 1980s through 2001. The photographic works selected are in keeping with the series of people and places of Oregon. Jim Lommasson's (b. 1950) *Elk Fountain* is the first color photograph for the collection, and suitably embraces its super-saturated night view of downtown Portland. A quiet counterpart, Robbie McClaran's (b. 1955) portrait of Oregon author Barry Lopez joins other fine portraits of figures such as Rachael Griffin and Ansel Adams. Two photographs were purchased from the estate of Terry Toedtemeier, representing the artist's most passionate geographical interests: remote sea caves (Figure 9) of the Oregon coast and the rocky outcroppings of the Columbia Gorge. Together with *Newspaper*, the Capitol Collection now holds a full complement of the late artist's major interests.

Two small oil paintings by long-time Salem resident Nancy Lindburg (b. 1934) were also selected for purchase. Lindburg was director of the Salem Art Association from 1973 to 1978 and the first artist

services coordinator for the Oregon Arts Commission from 1978 to 1991. Her legacy extends from her work on behalf of Oregon arts to a respected career as a painter, including abstract works and impressionist landscapes such as the two acquired by the Capitol.

The Oregon landscape is featured in the majority of the new acquisitions in varied forms, by turns lyrical, abstracted, and sharply focused. Margaret Coe's (b. 1941) *Crater Lake #2* represents the continuation of the painting traditions of those she studied under at the University of Oregon, including David McCosh (1903–1981), Andrew Vincent (1898–1993), and Frank Okada (1931–2000). A contemporary of Coe's, Laura Ross-Paul (b. 1950) received an MFA from Portland State University in 1976. Her use of landscape is as a rich, metaphorical backdrop to figures involved in an indefinite narrative. A faculty member of the Pacific Northwest College of Art since 1988, Tom Prochaska (b. 1945) creates *plein-air* compositions, often at Sauvie Island on the edge of Portland; they are impressionistic studies of light and color designed to reveal what the artist describes as "a little visual miracle."[25]

One of the most prolific and respected living artists in the region, James Lavadour (b. 1951) paints the eastern Oregon landscape under the inspiration of Asian landscape painting, American jazz, and abstract expressionism. His views of the land are by turns romantic and utterly contemporary. Lavadour's *Flag 2* (Figure 8), marks a significant development for the artist into architectural abstractions. The work, painted in 2001, was included in the Hallie Ford Museum of Art's 2008 Lavadour retrospective, "The Properties of Paint," which toured throughout Oregon. This painting was purchased with funds provided by The Ford Family Foundation's Visual Arts Program. It is the first work collected through its Art Acquisition Program, which seeks to place seminal works by Oregon artists into publicly accessible collections.

Representing the next generation of painters to inherit the modernist landscape, Michael Brophy (b. 1960) was a student at the University of Oregon when the Capitol Collection was being formed. He graduated from Pacific Northwest College of Art in 1985, where he is a faculty member today. The work selected for the Capitol, *The Rising of the Moon 2*, offers a compelling twenty-first century call and response to Charles Heaney's restrained eastern Oregon landscape *The Settlement*.

The final two acquisitions, a Willamette Valley landscape by Jon Jay Cruson (b. 1942), and a carved wooden wall panel by Leroy Setziol (1916–2005) differ in their materials but share a common vernacular of geometric patterning. For Cruson, pattern and highly keyed color help define and subvert landscape. For Setziol, sometimes referred to as "the father of Oregon woodcarving," pattern is the main subject, through which the material conditions of wood are revealed.[26]

These selections serve to extend the Collection, rather than simply filling in missing pieces. Considered as a group, their variations on landscape and expressionism offer interesting connections between the pure abstractions and early modernist landscapes of the 1970s works.

As the first project of Oregon's Percent for Art program, the Capitol Collection was assembled at a time before public art was a specialized field, as it has largely come to be today. Oregon's was one of the first of the now more than 500 state, city, and privately funded public art programs in the United States. Without predetermined expectations, a group of arts professionals grappled with goals and difficulties that are now common to public art selection committees: *How to create a cohesive collection from a shared vision? How to balance a desire for work that is particularly reactive to the architecture of the building with an interest in the exceptional work available in artists' studios? Which contemporary works will be important to future generations?*

The Capitol Art Collection was built with care, knowledge, and instinct. Thirty years later, it has proven to be a lasting legacy. As a collection of unequaled depth in our public holding, the collection documents Oregon's democratic, civic and aesthetic interests, and our talents and ambitions as artists, collectors and citizens.

NOTES

Unless otherwise indicated, information regarding artist history and committee process is taken from administrative files held by the Oregon Arts Commission. Some of these materials—such as artist statements, images, and details of the works in the collection—are also available through the University of Oregon Libraries Digital Collection, http://oregondigital.org/digcol/oac/

1 The original jury was composed of Larry Sprecher, Department of General Services; Marston Morgan, Capitol Planning Commission; Jack Thompson, Legislative Administration Committee; Robert Frasca, Wolf, Zimmer, Gunsul, Frasca Architects; and Peter Hero, director of the Oregon Arts Commission.

2 This screening committee included artist Michele Russo; Rachael Griffin, who had recently retired as curator of the Portland Art Museum; John Frohnmayer of the Portland law firm Tonkon, Torp & Galen (who later became the fifth chairman of the National Endowment for the Arts); Robert Hess, art faculty, Willamette University; La Verne Krause, art faculty, University of Oregon; Charles Rhyne, art history faculty, Reed College; and Shirley Gittleson, artist and Oregon Arts Commissioner.

3 An additional eight works were added to the Collection in 1985.

4 *Northwest Traditions*, exhibition catalogue, Seattle Art Museum, June 29–December 10, 1978.

5 *Northwest Traditions*, Seattle Art Museum.

6 Roger Hull, "Region, Expression, and 'Oregon Art' – 1930–1970," *Oregon Humanities*, Spring 2000. See also Roger Hull, *Charles E. Heaney, Memory, Imagination, and Place*, Hallie Ford Museum of Art, Willamette University, 2005.

7 Artist biography, David McCosh Collection, Jordan Schnitzer Museum of Art, http://jsma.uoregon.edu/collections/americas-regional-art/david-mccosh/biography.aspx

8 "Oral history interview with Louis Bunce, 1982, Dec. 3–Dec. 13," Archives of American Art, Smithsonian Institution, http://www.aaa.si.edu/collections/oralhistories/transcripts/bunce82.htm

9 "Painter Sally Haley dies at Age 99," United Press International, September 3, 2007, http://www.upi.com/

10 Bruce Guenther, Susan Fillin-Yeh, and David Curt Morris, *Hilda Morris*, exhibition catalogue, Portland Art Museum, April 15–July 16, 2006.

11 Tommy Griffin, 1976 exhibition brochure, University of Oregon Museum of Art, collection of Oregon Percent for Art Digital Collection, University of Oregon.

12 Roger Hull, "Jan Zach," *The Oregon Encyclopedia Project*, http://www.oregonencyclopedia.org/entry/view/zach_jan_1914_1986_. See also Roger Hull, *Intersections: The Art and Life of Jan Zach*, Hallie Ford Museum of Art, 2003.

13 DK Row, "Manuel Izquierdo, 1925-2009: an appreciation," *The Oregonian*, July 25, 2009.

14 Interview with the author, 2004.

15 Roger Hull, "George Johanson," *The Oregon Encyclopedia Project*, http://www.oregonencyclopedia.org/entry/view/johanson_george_1928_/ See also Roger Hull, *George Johanson: Image and Idea*, Hallie Ford Museum of Art, Willamette University, 2007.

16 "Oral history interview with Arlene Schnitzer, 1985, June 7–8," Archives of American Art, Smithsonian Institution.

17 "Oral history interview with Michele Russo, 1983, Aug. 29," Archives of American Art, Smithsonian Institution.

18 Statement by Governor Bob Straub. Oregon Arts Commission administrative records.

19 1979 PCVA membership mailing, Portland Center for the Visual Arts Archive, Crumpacker Family Library, Portland Art Museum.

20 Additional discussion focused on the possibility of commissioning a floor mosaic or artist-designed rugs, but neither of these ideas was pursued.

21 The $20,000 commission took a year to complete.

22 Roger Hull, "Art Views: A 'Capitol' Idea," *Northwest Magazine, The Oregonian*, August 29, 1976.

23 The committee included Herb Colomb, facilities manager of the State Capitol; Frankie Bell, long-time visitors' services manager and member of the Oregon State Capitol Foundation; Senators Richard Devlin and Ted Ferrioli; Representative Arnie Roblan; Judy Hall, secretary of the Oregon State Senate; Ramona Kenady, chief clerk of the Oregon House of Representatives; Kelly Howell, Pivot Architecture; historic preservation advocate Elisabeth Walton Potter; John Olbrantz, director of the Hallie Ford Museum of Art; and Christine D'Arcy, executive director of the Oregon Arts Commission and Oregon Cultural Trust. During the committee's tenure, Herb Colomb retired and was succeeded on the committee by Scott Burgess, legislative administrator.

24 In the three decades since their initial installation, only seven works were unable to be located or had previously been destroyed. Thirty-five works were inspected by a professional conservator, and thirteen works underwent cleaning and repair by specialists in objects, painting, photography, paper and textiles. Approximately fifty works on paper were treated, replacing non-archival materials that would have shortened the lifespan of the art.

25 "Paintings and Prints of Tom Prochaska Exhibited in Governor's Office," Oregon Arts Commission press release, March 4, 2005.

26 See OPB Art Beat, "Wood Carver Leroy Setziol,"http://www.opb.org/programs/artbeat/segments/view/182

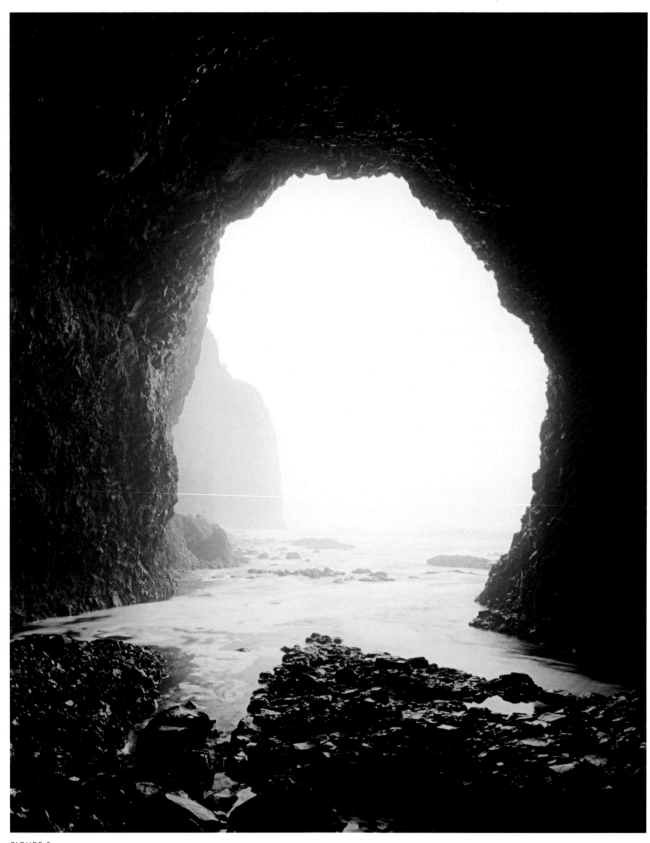

FIGURE 9.

Terry Toedtemeier (1947-2008). *Fog at Entrance to Sea Cave, Cape Mears, OR*. 2001. Gelatin silver print.
This work exemplifies the photographer's series of studies of the Oregon coast, made during extreme minus tides, which allowed him brief access to sea caves and other usually submerged locations.

A Collection of Photographs

Jennifer Stoots and Lawrence Fong

In 1977, the Oregon State Capitol's collection of photographs, titled Oregon in the 20th Century, was formally introduced as a visual record of the state by Peter Hero, then executive director of the Oregon Arts Commission. The collection was built at the direction of the Capitol Wings art selection jury, which invited a panel of photography professionals to curate the collection[1]. The panel sought to represent photographers living in Oregon, along with well-known photographers who had worked in the state.

The works were selected after substantial historical research and an invitational competition involving over 300 Oregon photographers. The collection was meant to constitute a beginning, and those behind the project hoped it would be expanded throughout the remainder of the 20th century. Indeed, three additional works were purchased in 1985, and—as part of the total reinstallation of the collection in the renovated Capitol Wings—another four were purchased in 2010. Oregon in the 20th Century is not only a tribute to Oregon's people and land; it also demonstrates the development of photography as an art form.

The pioneering West was chronicled by photography, a new technology, as early as 1840. The discovery of gold in California in 1847 led to waves of immigration, and in 1862 President Abraham Lincoln authorized construction of the first continental railroad by signing the Pacific Railway Act. Subsequently, photographer William Henry Jackson was commissioned by the Union Pacific Railroad to document the proposed routes for use in their advertising campaigns. Such commercial promotion, coupled with the photography studios of already established settlers, marked the dawn of "Photography and the West."

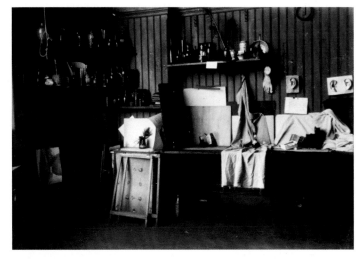

FIGURE 10.
Julia Hoffman (1856–1934). *Studio*. 1895. Gelatin silver print.

The state's early photographic heritage is particularly striking, and sets the stage for the artists and work that followed. Among the early pioneers represented are Peter Britt (1819–1905), who had settled in Jacksonville in 1852, and Benjamin Gifford[2] (1859–1936), who lived first in Portland and moved to The Dalles in 1895. Julia Hoffman (1856–1934), an accomplished amateur photographer, moved to Portland in 1881; she was an integral figure in establishing the Portland Arts and Crafts Society and founded the Oregon College of Art & Craft in 1907. Images by these artists (Figure 10) are rare expressions of their time and place in Oregon; they also mark the dawn of a new era.

By the early twentieth century, photography was becoming an accepted art form. Alfred Stieglitz was cultivating an audience for the medium through his New York gallery "291" and via a quarterly publication, *Camera Work*. Artists vied to associate themselves with Stieglitz's Photo-Secession movement and his invitation-only camera club. Of the six associate members on the West Coast, two were from Oregon—Lily White (1866–1944) and Sarah Hall Ladd (1857–1927) of Portland. Both women appreciated landscape and portraiture but also documented social and industrial activity in their photographs. These subjects and themes repeat consistently throughout the collection, along with purely artistic creations, including still lifes and conceptual imagery.

The portraits included in *Oregon in the 20th Century* range in style from formal sittings to personal perspectives, and prominently feature "ordinary" people. One of the more recognized figures is the photographer Ansel Adams, whom Marian Kolisch (1920–2008) photographed around 1975. Just as distinguished, though known primarily to students of music, is Ernest Bloch (1880–1959), an eminent composer who emigrated to the United States from Switzerland in 1917. In his later years, Bloch retreated to the Oregon coast to indulge another passion, photography. His *Self-Portrait (Working on a Score)* was taken in 1948 at his house in Agate Beach. In fact, the majority of the portraits in the collection capture unassuming moments, for example Julia Hoffman's picture of her daughter, Margery Hoffman, circa 1894; Peter Britt's *Mollie Britt in the Parlor*, 1896; Selina Roberts' (1948–1990) humble portrait of Edith Nelson, 1974 (Figure 11); and Robert B. Miller's (b. 1948) *Leigh Clark-Granville, Actress*, 1979 (Figure 12).

In the genre of landscape, many photographers rendered Oregon's varied terrain with reverence and clarity, as exemplified by David Bayles' *Bandon Beach*, 1972; Lawrence Hudetz's (b. 1937) *Mt. Hood: Trillium Lake*, 1972; and Bernard Freemesser's (1926–1977) *Painted Hills*, 1972. In slight contrast, softer-toned pastoral scenes such as Ray Atkeson's (1907–1990) *Sheep Pastoral*, 1935, and Wayne Aldridge's

FIGURE 11.
Selina Roberts Ottum (1948-1990). *Edith Nelson*. n.d. Gelatin silver print.
FIGURE 12.
Robert B. Miller. *Leigh Clark-Grainville*. 1979. Gelatin silver print.

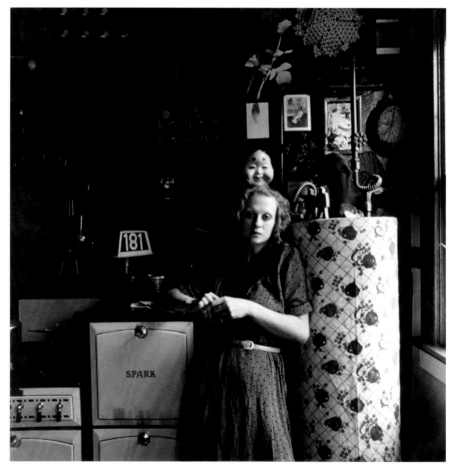

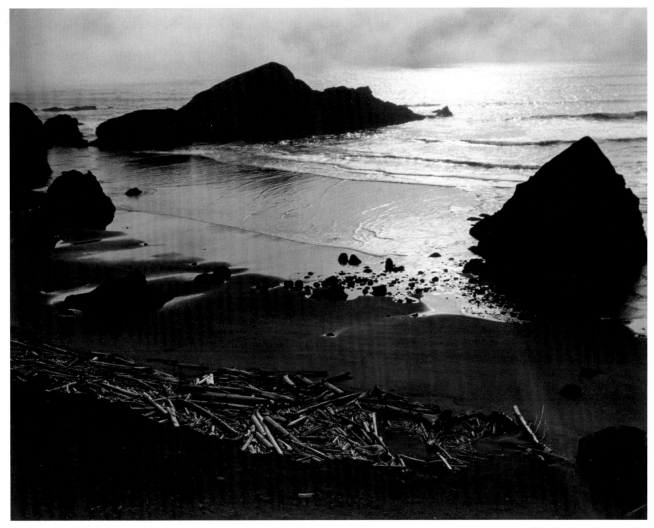

FIGURE 13.
Edward Weston (1886-1958). *Fog, Oregon Coast*. 1939. Gelatin silver print.

Cows, 1975, transport the viewer to Oregon's idyllic countryside. Also included in the collection is Ansel Adams' *Cape Sebastian*; Morley Baer's *Humbug Mountain, Oregon Coast*, 1962; and Edward Weston's *Fog, Oregon Coast*, 1939 (Figure 13)—evidence that Oregon's majestic landscape captivated the most talented photographers.

Social documentary has long been of paramount importance to the arts. Oregon's photojournalists included Al Monner (1909–1998), a staff photographer at the *Oregon Journal*; Priscilla Carrasco (b. 1933), who has devoted her career to exposing social injustice; and Michael Mathers (b. 1945), who early in his career captured the lives of hoboes, ranch hands, and circus performers. A more whimsical approach is evident in the work of Cheryl Reed (b. 1947) whose *Destiny Afternoon*, 1976, captures the fanciful nature of children, while James Cloutier's (b. 1938) *New American Gothic*, 1968, highlights how little the world seems to change in rural America.

Taking the camera into the studio, several photographers represented in the collection addressed the traditional genre of still life with a painterly style, such as Robert Wilson, whose *Milkcans* recalls classic *trompe l'oeil*, or the clean, pure rendering of *Shell #5* by Maxwell Allara (1906–1981). Joe Erceg's (b.1933) photogram *Grapes*, 1976, on the other hand, is somewhat contrasting for its graphic nature, and foreshadows Erceg's enviable career as one of Portland's most respected graphic designers.

The Oregon State Capitol is also custodian of early works of some of Oregon's best-known

FIGURE 14.
Christopher Rauschenberg. *Untitled*. 1973. Gelatin silver print.

photographers, most notably four of the five founders of Blue Sky Gallery (est. 1975) in Portland: Robert Di Franco (b. 1950), Craig Hickman (b. 1948), Christopher Rauschenberg (b. 1951) (Figure 14), and Terry Toedtemeier (1947–2008) (Figure 9). Blue Sky Gallery continues to be one of the most prestigious venues for new photography in the state, with a national reputation for exhibiting undiscovered talent.

Though there are few photographs from the 1920s and 1930s in the collection, Oregon in the 20th Century includes photographs from every decade from the late nineteenth century to 2001. Not surprisingly, most are by photographers who were living in Oregon at the time of acquisition (1977, 1985, and 2010). Exceptions were made for artists whose work took them to Oregon, such as Ansel Adams, Edward S. Curtis (1868–1952), Brett Weston (1911–1993), and Edward Weston (1886–1958), each of whom is considered a significant figure in twentieth-century art and photography. Oregon in the 20th Century is just as Mr. Hero intended—a record of place, of time passed, of ideas, and of the people who've been here. As such, the Collection reveals itself as a testament to Oregon's diversity, then and now.

NOTES

1 In 1977, the photo collection was curated by a panel composed of Bernard Freemesser, Rachael Griffin, Marian Kolisch, David Mendoza, Robin Rickabaugh, and Garry Young. 1985 acquisitions were guided by an advisory committee comprising Marian Kolisch, Priscilla Carrasco and Larry Hudetz.

2 At the time of printing, Benjamin Gifford's photograph *Boy with Umbrella*, in sadly poor condition, is recommended to be removed from the Collection.

Plates

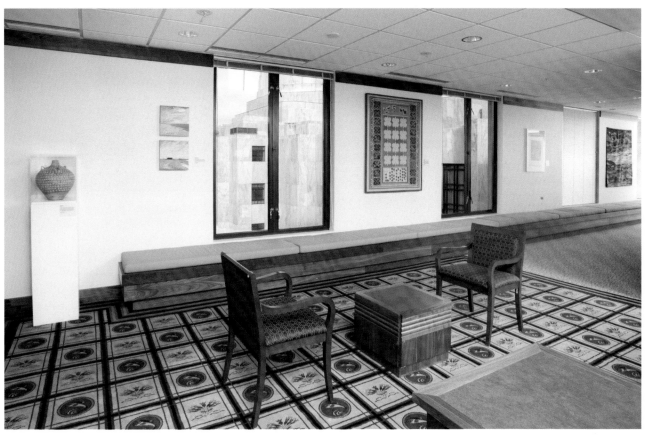

Figure 15.
The renovated Capitol Wings, as designed by Pivot Architecture, Senate fourth floor lobby. Shown: Albert Borch. *Untitled*. ca.1976. Ceramic. Nancy Lindburg. *Dakotascape I* and *Dakotascape II*. 2010. Oil on board. Harry Widman. *Rug Invention Series*. ca. 1975. Kathleen Rabel. *Calgary*. 1976. Intaglio. Pam Patrie. *Untitled*. ca. 1976. Textile.

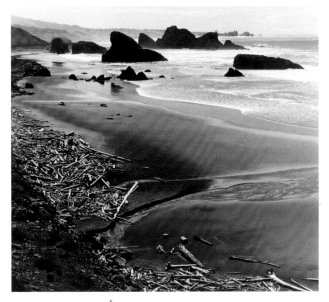

Ansel Adams (1902–1984)
Cape Sebastian, 1960
Gelatin silver print

Ansel Adams ranks among the most important and influential photographers of the 20th century. He is the creator of the Zone System, a way to measure and control film's exposure and development, and a founder of Group f/64, which advocated using the camera's capacity for extreme focus and detail in "previsualizing" a composition. Although his photographs include portraits and documentary work, Adams is best known for his dramatic landscapes, particularly of Yosemite. Like those photographs, *Cape Sebastian* is notable for its strong contrasts of light and dark as well as subtle, silvery midtones.

Wayne Aldridge
Cows, 1975
Gelatin silver print

Throughout his career, Wayne Aldridge has been drawn to the landscape of the Pacific Northwest, from the lush hills of the wine country to the dramatic vistas of the Columbia River Gorge and eastern Oregon. In this early work, with its lacy trees and palpable mist, Aldridge finds romantic poetry in an everyday scene of grazing cattle. The photograph evokes the soft-focus images of late 19th-century photography.

Maxwell Allara (1906–1981)
Shell, 1975
Gelatin silver print

Max Allara was a member of the Interim Workshop, a group of Portland photographers whose work was profoundly influenced by the modernist sensibilities of Minor White. Allara's work also pays tribute to West Coast artists such as Imogen Cunningham and Edward Weston, who often photographed isolated vegetables or flowers. Like them, Allara has used sharp focus and direct light in this image of a shell, where imperfections add subtle drama to the simple composition.

Bonnie Allen
Contemplation, 1977
Acrylic on canvas

A painter and printmaker, Bonnie Allen graduated from the Museum Art School (now the Pacific Northwest College of Art), where she has taught for many years. Works like *Contemplation* show Allen's commitment to what might be called a tradition of representational painting in the Pacific Northwest, which thrived even as much of the art world turned to minimalism in the 1970s. This interest in the figure can also be seen in the works of such artists as Michele Russo, George Johanson, and Harry Widman, other artists with longstanding ties to PNCA.

Glen Earl Alps (1914–1996)
Color Modification, ca. 1976
Collagraph print

Although he also created sculpture, paintings and drawings, Glen Alps is renowned as an innovative printmaker and teacher. He is responsible for coining the term "collagraph" to describe a technique in which prints are pulled from a plate that has been built up with collaged materials, such as wood and scraps of mat board. Alps also championed serigraphy as a fine-art form and worked with other printmaking methods, including lithography. *Color Modification*, with its explorations of textures and tonalities, exemplifies the simple, abstract compositions Alps favored.

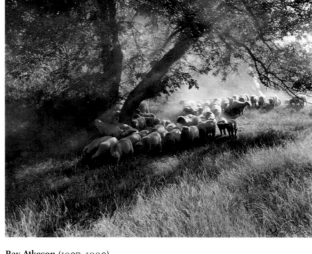

Ray Atkeson (1907–1990)
Sheep Pastoral, 1935
Gelatin silver print

Ray Atkeson was named Oregon's Photographer Laureate in 1987. His photographs of mountains, the coastline, rivers and waterfalls are, to many, the defining images of the state, and were seen by millions of magazine readers across the country. *Sheep Pastoral*, one of Atkeson's most beautiful and elegiac images, dates from the years when he was working for a commercial photographic studio, but spending his free time hiking and photographing the Northwest landscape. Its formal appeal lies in the wonderful sense of depth—note the diagonal lines of the tree and clustering sheep—and in the silky quality of the diffused light.

Jay Backstrand
Three untitled drawings, ca. 1976
Graphite on paper

Because of his consummate command of line and composition and his encyclopedic knowledge of art history, Jay Backstrand's paintings and drawings can seem both familiar and mysterious at the same time. One is tempted, in "reading" this sequence, to invoke the early photographic motion studies of Eadweard Muybridge, or the 19th-century American painter Thomas Eakins, who—like Backstrand—was fascinated by hidden narratives and psychological enigmas. Backstrand's work can be found in major American museums. He graduated from the Pacific Northwest College of Art and received a Fulbright Scholarship to study at the Slade School of Fine Art, University of London.

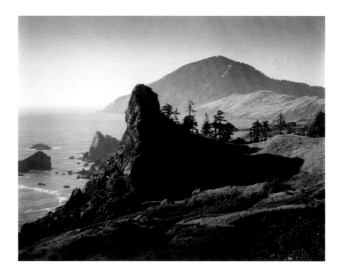

Morley Baer (1916–1995)
Humbug Mountain, Oregon Coast, 1962
Gelatin silver print

Morley Baer's long career unfolded in northern California, where he was a friend of Edward Weston and, like him, made photographs of the coastline and landscape of the Monterey Peninsula. He was also a noted architectural photographer with an international reputation. Baer, like Weston and others of the California school, shunned the grandiose in favor of searching out the beauty in less bombastic scenery. With its simplicity and elegant composition, this image of Humbug Mountain is typical of his restrained style. Baer preferred to use an 8x10-format camera and his work is almost exclusively in black and white.

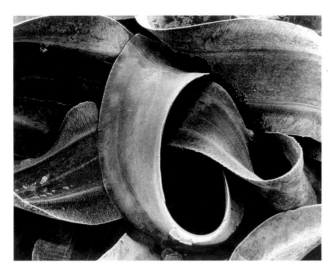

Mark Bailey
Rubber Forms, 1977
Gelatin silver print

An active photographer based in Eugene in the 1970s, little is documented of Mark Bailey's life or career. *Rubber Forms* beautifully tricks the eye with curls of rubber, softly textured to read as plant fronds. The work is in the tradition of formalist studies, which marked much photography in the 1970s.

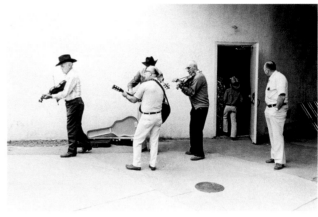

John Bauguess
Oregon Old Time Fiddler (Series), 1976
Gelatin silver print

John Bauguess studied photography and writing at the University of Oregon and the San Francisco Art Institute. His long photographic career has included work as a journalist, a book illustrator, and a teacher. In addition to producing myriad individual images, Bauguess has often focused on special projects such as the *Oregon Old Time Fiddler* series, on which he collaborated with folklorist Linda Danielson. In this image, Bauguess captures four musicians warming up as their audience enters the performance hall. The Fiddlers Association is still going strong, and sponsors contests and weekly Sunday afternoon jam sessions.

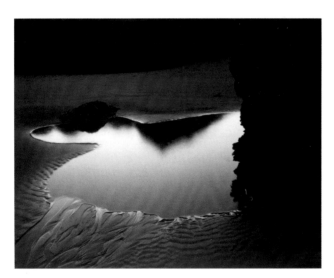

David Bayles
Bandon Beach, 1972
Gelatin silver print

At the time this photograph was made, David Bayles was at the start of his career—a young landscape photographer working in the tradition of (and under the influence of) Brett Weston and Ansel Adams. While he moved away from this early photographic style, with its emphasis on iconic landforms and dramatic lighting, Bayles never lost his interest in photographing nature; in recent years, his imagery has been shaped by his involvement in the conservation of wild and scenic rivers and by his questioning of our particular relationship to the landscape of the American West.

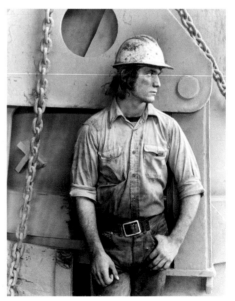

László Bencze
Steelworker, 1977
Gelatin silver print

László Bencze's long career as a commercial photographer has taken him to industrial sites, mines, and high-tech laboratories in far-flung locations, in search of images of what he has described as "the underworld of an industrial society." His interest in these places lies in the raw drama of the locations themselves and in the people he meets. In *Steelworker*, Bencze creates not only a portrait of an individual but also a subtly witty composition. Note the repeated circular shapes and the triangular framing formed by the massive chains. Bencze used the name "Louis" for much of his career.

Ernest Bloch (1880–1959)
Self-Portrait, 1948
Gelatin silver print

Composer Ernest Bloch made this portrait of himself while he was working on a score at his beloved house in Agate Beach, Oregon. Although he is certainly better known for his music, Bloch was a talented photographer whose subjects include images of his family and of the Oregon landscape. In the 1970s, Eric Johnson, an undergraduate student at the University of Oregon, rediscovered Bloch's photographs and worked with his family to archive them and make some 100 prints from the more than 6,000 extant negatives.

Marv Bondarowicz
Untitled, 1973
Gelatin silver print

In the 1970s, Marv Bondarowicz produced a striking series of photographs of the human form. By isolating elements of the body—a tongue, a nipple, or an expanse of goose-bumpy skin—and using high-contrast lighting, he created abstract and ambiguous images that are frequently unsettling. His 1977 book *Snapshots*, which has become something of a cult classic, reproduced a number of these prints. Bondarowicz is also known as a one-time staff photographer for *The Oregonian*.

Albert Borch
Untitled, ca. 1976
Ceramic

During the 1970s, Albert Borch explored elemental forms and glazes, producing a series of vessels that, like this one, reference ancient ceramic traditions and patterns. Borch, who is currently working on small-scale ceramic sculptures, received his MFA from the California College of Arts and Crafts, and taught at the School of the Art Institute of Chicago and the Alberta College of Art and Design. He is also an accomplished bookbinder.

Frank Boyden
Untitled Vase, ca. 1976
Ceramic

Frank Boyden, a native-born Oregonian who began making ceramics in the 1970s, has experimented with various clays, glazes and firing techniques over the course of his long career. In this early vessel, Boyden shows his interest in traditional forms, such as the vase and bowl, and his fascination with surface. The monochrome glaze, variable textures and irregular incised lines complement the simplicity of this elemental form.

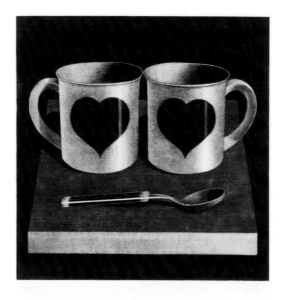

Byron H. Bratt
The Kiss, 1977
Mezzotint

Byron Bratt is known for his ability to find poetry in everyday objects and settings, such as a pair of ordinary mugs and a shared spoon placed against a neutral background. Bratt is a masterful printer, and in this still-life composition, his use of mezzotint—the term is derived from the Italian word for "half-tone"—lends his subject dramatic shading and high contrasts of light and dark.

Byron H. Bratt
The Witness, 1978
Intaglio print

Byron Bratt often delves into the lives of inanimate objects, finding romance, poetry and mystery within the confines of a simple still-life composition. *The Witness*, with its cryptic title, invites us to contemplate the life of an apple as it is skinned and cored by an old-fashioned apple peeler. Bratt's print contains an allusion to Paul Cézanne's famously animated apples, which are often set against the plane of a tilted table top such as this one.

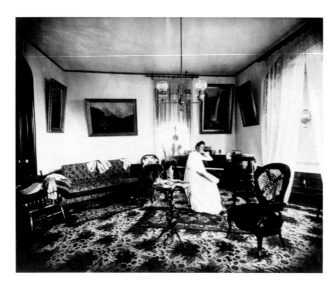

Peter Britt, (1819–1905)
Mollie Britt in the Parlor, 1896

Peter Britt, who emigrated from Switzerland to the United States, arrived in Jacksonville, Oregon, in 1852 and had established himself as a photographer by 1856. His legacy includes not only portraits, but also images of the southern Oregon landscape and of daily life. Here, we see his daughter Mollie seated at her Steinway piano in the Britt's spacious Victorian house. Note the many landscape paintings and the flower arrangement—Britt was also an accomplished horticulturalist.

Nikki Bromberg
Sherwood Attic, 1975
Gelatin silver print

Nikki Bromberg's spare photograph is a study of hard-edged shapes, diagonal lines, and contrasts of black, white, and shades of gray. Only the scuffed floor and the slight warp of the wood stove's hearth deviate from the strict geometry of this impersonal interior, a far cry from the clutter usually evoked by the word "attic."

Drex Brooks
Still Life, Vase, 1976
Gelatin silver print

In its sensitivity and attention to the small details of wilted flowers, fallen petals, and filtered light, this elegant image is typical of Drex Brooks's approach to photography. Brooks, who spent part of his childhood in eastern Oregon, received his MFA from the Rhode Island School of Design. Much of his recent work has focused on Indian reservations and on important sites in Native American history; in these photographs, he brings to bear the same quiet intensity that marks this early still life.

Michael Brophy
The Rising of the Moon 2, 2008
Oil on canvas
2010 Acquisition

Representing the next generation of painters to inherit the modernist landscape, Michael Brophy was a student at the University of Oregon when the Capitol Collection was being formed, and graduated from Pacific Northwest College of Art in 1985. Brophy is known for large-scale landscape paintings of iconic Western views: sweeping deforested hillsides, imposing visions of big-rigs, towers of stacked shipping containers. *The Rising of the Moon 2* offers a compelling 21st century counterpart to Charles Heaney's restrained eastern Oregon landscape *The Settlement* (page 42).

Louis Bunce (1907–1983)
Midway #5, 1975
Oil on canvas

Louis Bunce's restless curiosity produced a fascinating body of work—paintings and prints that responded to the world of art in a way that was hardly equaled by other Northwest artists of his time. He studied in Portland and at the Art Students League of New York, and was connected with such important figures as Jackson Pollock. But even as he was exploring surrealism, abstraction, and social realism, Bunce remained firmly grounded in the Pacific Northwest—its land forms, light, and palette were a vital element of his art. In *Midway #5,* Bunce uses slabs of color and spare lines to construct a landscape that references the minimalism of color field painting and the vast spaces of Oregon's deserts and coastline.

James Burgess
Grainery Stacks, Oregon, 1977
Gelatin silver print

In the 1920s, artists began to explore a new aspect of the American landscape: the industrial and agricultural buildings that had become an important element of both urban and rural scenery. Following in the tradition of artists such as Charles Sheeler, James Burgess emphasizes both the scale and the unexpected elegance of a group of grain towers, finding beauty in their functional architecture.

Michael Burns (1943–1991)
Dormer, 1976
Paint on panel

The abandoned buildings that are found in the rural areas of Washington and Oregon were a primary focus of Michael Burns' work. He used a camera to document architectural details, such as the structure of this roofline and the sharp point of the dormer. In *40 Watercolorists and How They Work*, Burns noted, "I think the distinctive aspect of my paintings is their simplicity, both in composition and subject. I treat each painting as a portrait, with the building being the subject. Only what is absolutely necessary in telling its story is included." Burns was an illustrator, best known for his watercolors.

Owen Carey
Main Street, Wasco, ca. 1976
Gelatin silver print

With its rain-soaked sidewalks, beat-up building and hand-lettered sign advertising "RocKs," Owen Carey's moody image captures the grittiness of small-town Oregon. But Carey's image is more than anecdotal—note the careful arrangements of rectangular shapes and hard lines, such as the power pole paralleling the tree and forming a perfect right angle with the building's shabby molding. Carey, who is a commercial photographer in Portland, continues to make landscape images in addition to his portrait commissions.

Ed Carpenter
Untitled, n.d.
Stained glass

Known internationally for his public and private installations, Ed Carpenter is one of the best-known artists working in the medium of glass. In the 1970s, he studied glass as an art form and an architectural element, and that dual approach to the medium has characterized his work ever since. In this early piece, Carpenter shows his interest in fusing traditional techniques and materials with a modern, abstract vocabulary. Carpenter maintains his studio in Portland and his large-scale installations can be found in many public spaces in the Pacific Northwest and beyond.

Priscilla Carrasco
Ungers Farm Labor Camp, 1967
Gelatin silver print

Priscilla Carrasco has often used her camera as a tool for social and cultural documentary. In this timeless image, which could have been made in the 1930s as easily as in the 1960s, Carrasco captures the utter absorption of childhood, but also the living conditions in a farm labor camp—the wood-frame cabin in the background, with its worn wooden stoop, and the fragment of a toy with which the boy is playing. Carrasco recently published a book of her photographs of the Woodburn, Oregon community of Russian Old Believers.

Priscilla Carrasco
Farm Labor—Day Haul to Salem, 1966
Gelatin silver print

Priscilla Carrasco's weathered workers are reminiscent of figures from
the Farm Security Administration photographs made during the Great
Depression. This image gains its sense of drama from the grainy exposure,
the high-contrast lighting, and the diagonal chain stretching across the
foreground. In the course of her career, Carrasco has focused on making
photographs that expose social injustice and honor indigenous cultures,
both in this country and elsewhere.

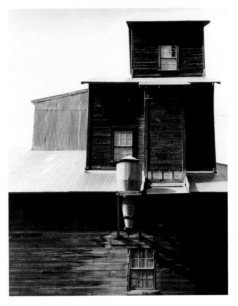

George T. Carver
Maupin, Oregon No. 2, ca. 1976
Gelatin silver print

A study in texture and light, George Carver's photograph is an examination
of the unexpected elegance of vernacular architecture. Eliminating all details
of setting save for the uniform background of the sky, Carver emphasizes
the spare geometry and simplicity of this three-story rural building. The im-
age is reminiscent of earlier photographs and paintings by Charles Sheeler
and Charles Demuth, who, like Carver, found beauty in structures made for
farming and industry.

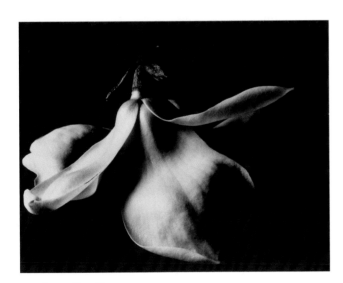

Pamela Powell Caulley
Tulip, Stayton, 1974
Gelatin silver print

Pamela Powell Caulley's photograph pays homage to such artists as Edward
Weston and Imogen Cunningham, whose still-life studies of plants, fruits
and vegetables emphasized the sensualities of shape and texture. In
Caulley's beautifully handled composition—a study in contrasts—we are
drawn to the perfection and purity of a simple magnolia blossom, posed and
lighted as carefully as a beautiful female form.

Karen Chen-Blakely
Rain Water and Tusche Dried, 1976
Color lithograph

By combining geometric patterns and gestural elements with a "window"
of cloudy sky, Karen Chen-Blakely creates a fascinating push–pull between
foreground and background, and between two and three dimensions.
Where the sky provides an illusion of depth, the overlay of abstract lines
and diagonal border establish the essential flatness of the composition,
removing it from the realm of representation.

James Cloutier
New American Gothic, 1968
Gelatin silver print

In James Cloutier's photograph, carefully observed details of costume and setting contribute to a portrait of small-town American life. In this case, the town is Alpine, Oregon, where Cloutier made many photographs in the 1960s and 1970s. As with the Grant Wood painting from which this image derives its title, the artist approaches his subjects with both affection and humor. And, as with Wood's subjects, one senses a certain wariness or discomfort in these two people, staring into the sunlight at the camera's lens, the man caught with his Blitz beer, the woman with her heavy, wrinkled hose. Cloutier used this image on the cover of his book *Alpine, Oregon: Photographs of a Small Town in America*, published in 1977.

James Coates
A Water Pipe Dream or Is It?, ca. 1976
Lithograph

In this curious image, James Coates works with scale, light and location to suggest a disorienting space and series of forms. His title, with its own question, further compounds the viewer's sense of mystery and dislocation. Here, Coates is working with some of the underlying ideas of surrealism, rendering the commonplace—here, presumably, some aspects of plumbing—unfamiliar and juxtaposing objects that don't ordinarily go together.

Margaret Coe
Crater Lake 2, 2010
Oil on canvas
2010 Acquisition

Margaret Coe, a long-time resident of Eugene, received her MFA from the University of Oregon in 1978. The lively movement and color in her work continues the painting traditions of her teachers David McCosh, Andrew Vincent and Frank Okada. Coe taught art for many years at the University of Oregon, Lane Community College and the Maude Kerns Art Center.

Dennis Cox
Menagerie, ca. 1976
Intaglio

The seven female figures whose faces and hands emerge from the moody background of Dennis Cox's *Menagerie* appear linked by a common narrative, a story told through their solemn expressions and the variety of hats and scarves they wear. Below are three identical silhouettes, in a gradation of pale gray to black. One wonders if the title refers to racial diversity, to the rich menagerie of a human population.

Duane Cox
The Ocean Floor, ca. 1976
Serigraph

Duane Cox is one of many artists who explored the serigraph during the 1960s and 1970s, at a time when Pop artists such as Andy Warhol had begun using screen printing as a fine art form. With its brightly-colored checkerboard pattern, Cox also references the pop and op ideas of that era. In addition, his work explores the idea of form, by taking the image of a crustacean and rendering it three times above the checkerboard—once realistically, twice as if it were a simply a flattened shape.

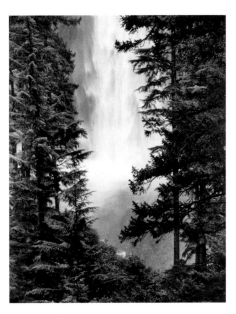

Steve Crouch
Salt Creek Falls, 1964
Gelatin silver print

Although not as well known as Multnomah Falls, Salt Creek Falls, near Cottage Grove, is the second largest waterfall in Oregon. Steve Crouch, who studied with Ansel Adams, captures the power of pounding water, intensifying its impact with his foreground frame of two massive trees. With its implication of wilderness—there is no evidence of human presence—the image has the romanticism of a 19th-century landscape painting and also references the work of early photographers—Carleton Watkins, for example—who made their way to Oregon beginning in the 1860s.

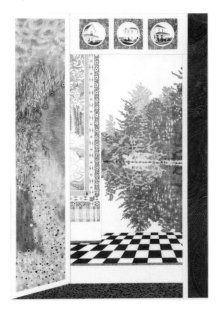

Jon Jay Cruson
View from the Studio, n.d
Mixed media

An experienced draftsman, printmaker and painter, Jon Jay Cruson's works show a great variety of interest in texture, line and color. Cruson has lived, taught and worked in Salem, Eugene, and Corvallis, while also keeping a studio full- and part-time at Seal Rock on the Oregon coast. He draws influence from Chinese and Japanese art as well as both Art Deco and Art Nouveau.

Jon Jay Cruson
Vista 14, 2009
Acrylic on canvas
2010 Acquisition

An experienced draftsman, printmaker and painter, Jon Jay Cruson's works show a great variety of interest in texture, line and color. Cruson has lived, taught and worked in Salem, Eugene, and Corvallis, while also keeping a studio full- and part-time at Seal Rock on the Oregon coast. His travels through the Willamette Valley are evident in landscape works such as *Vista 14*.

Edward S. Curtis (1868–1952)
Dip-Netting in Pools, Wishram, 1909
Photogravure on tissue

The North American Indian, Edward S. Curtis' life work, eventually comprised 20 volumes and portfolios of photographs. It was a vast compendium of images in which Curtis aimed to depict the life and traditions of Native Americans before their contact with Europeans. This image appears in the portfolio accompanying Volume 8, which is devoted to the Pacific Northwest and particularly to the Columbia River. Curtis's caption reads, "In the quiet pools along the rocky shore the salmon sometimes lie resting from their long journey upstream. The experienced fisherman knows these spots, and by a deft movement of his net he takes toll from each one."

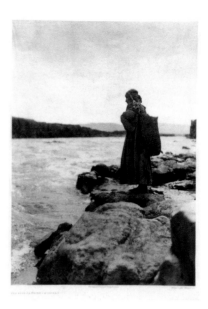

Edward S. Curtis (1868–1952)
The Fish Carrier, Wishram, 1909
Photogravure on tissue

The North American Indian, Edward S. Curtis' life work, eventually comprised 20 volumes and portfolios of photographs.It was a vast compendium of images in which Curtis aimed to depict the life and traditions of Native Americans before their contact with Europeans. This image appears in the portfolio accompanying Volume 8, which is devoted to the Pacific Northwest and particularly to the Columbia River. Curtis's caption reads, "From the fishing station the salmon are carried to the house, distant perhaps a quarter of a mile or more, in an open-mesh bag ("ihlkabenih") borne on the back and supported by means of a tump-line passing across the forehead."

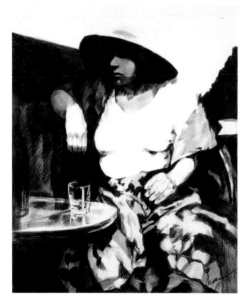

Bruce Goring Dean
Lois #2, 1974
Graphite on paper

Bruce Goring Dean is known both for his sculpture and for his skills as a draftsman—he taught drawing at Lane Community College for many years. In *Lois #2*, Dean focuses his attention on the weighty curves of his model's body: her arms, torso and thighs. But this drawing is also a wonderful study of contrasts, and of the subtleties a skilled draftsman can coax from a monochrome palette.

Drake Deknatel (1943–2005)
Aerial, 1976
Acrylic on canvas

Drake Deknatel is known as much for his representational paintings as for his love of abstraction. To both, he brought a love of the physical act of painting and his works are noted for their complexity and for his ability to find a sense of perfect resolution, as if each composition were a response to a metaphysical as well as a formal investigation. Based in Seattle, Deknatel also spent much of his time in later years in Berlin, where his work found a receptive audience.

Robert Di Franco
Untitled, Eunice's Porch, 1977
Gelatin silver print

Robert Di Franco was one of the founding members of Portland's Blue Sky Gallery, which still flourishes today. In the 1970s, Di Franco made extensive use of a strobe light, along with long exposure times. Thus his prints are a blend of various kinds of light, and the deliberately blurred elements of the image add to the confusion, creating what one fellow photographer referred to as "altered spatiality."

Robert Di Franco
Sabines Revisited, 1977
Gelatin silver print

Robert Di Franco's interest in capturing ambiguities of light and space is here further complicated with references to art history. The curtain that gives the work its title and covers two-thirds of the image is printed with a confusing mélange of bodies, mostly female, mostly nude. The allusion is to historical paintings and sculpture of the abduction of the Sabine women by the founders of Rome. A tattered print of a van Gogh painting is partly visible as well.

Joseph Erceg
Door/Reflection, 1972
Gelatin silver print
1985 Acquisition

Joe Erceg is known as one of Portland's preeminent graphic designers, but he is also a gifted photographer. In this image, Erceg explores the abstract potential of photography by focusing on the irregular lines of the puddle and the fascinating composition of the reflection it captures. The slight texture of the water's surface and the distortion of the image make a simple subject unexpectedly fascinating.

Joseph Erceg
Grapes, 1976
Photogram

Known for his graphic design, Joe Erceg is also a gifted photographer, with a deep interest in photographic processes. Grapes is a wonderful example of a photogram, a one-of-a-kind, camera-less image made by placing objects—in this case, individual stemmed grapes—on photographic paper, then exposing the composition to light. This technique has been used often in the history of photography, and was especially favored by the Surrealists in the 1920s and 1930s.

Judith Poxson Fawkes
Untitled, 1977
Textile

In her tapestries, Judith Poxson Fawkes explores color, imagery, and abstraction, as well as weaving techniques and materials. In the eight individual pieces that comprise this weaving, Fawkes presents a theme and variations by using the same palette and pattern of dominant vertical stripes. The work subtly references minimalism's interest in serial compositions, but replaces its impersonal austerity with elegant craft and lyrical colors. Fawkes received her MFA from Cranbrook Academy of Art.

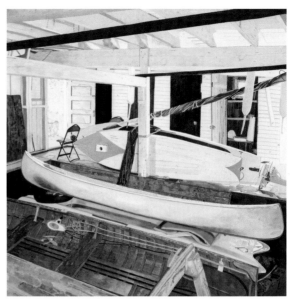

Tom Fawkes
The Boathouse at Fresh Breeze, 1976
Oil on canvas

Over the years, Tom Fawkes has gained a reputation for his own brand of meticulous realism, which is often reminiscent of the photorealist movement of the late 1960s and 1970s. But Fawkes focuses not on the banality of everyday scenes, but rather on formal gardens, elegant doorways, and the details of carefully observed interior spaces. *The Boathouse at Fresh Breeze* exemplifies Fawkes's virtuosic command of color, composition and draftsmanship.

Betty Feves (1919–1985)
Garden Wall, n.d.
Glazed ceramic on wood slab base

Recognized internationally as a leading ceramic artist, Betty Feves spent her career in Pendleton, Oregon. She is known for sculptures such as this one, with its emphasis on truth to materials and straightforward processes. Feves focused on the human form, even when abstracted, as is the case with Garden Wall, where rounded "heads"—made of coiled pots—suggest a gathering of people. She allowed her clay forms to dry naturally, then applied an ash or slip glaze before firing.

Marilyn Foss
Dunes and Pussywillows, 1977
Gelatin silver print

Marilyn Foss's elegant and minimalist composition of windblown sand and leafless twigs gains its effect from the photographer's attention to capturing every nuance of texture and line. Each element is delineated, from the delicate pencil-thin shadows to the wave-like patterns in the sand. The work is reminiscent of the aesthetic championed by such mid-20th century photographers as Minor White, whose compositions focused on telling details, rather than grander vistas. Foss received her MFA in photography from the University of Oregon.

Constance Fowler (1907–1996) ·
Oregon Clam Diggers, n.d.
Oil on board

Constance Fowler spent her career in the Pacific Northwest, much of it in Oregon, where she taught at Willamette University and was also associated with the University of Oregon. Although she was a gifted printmaker and watercolorist, her strength lies in her landscapes and seascapes. Fowler worked to incorporate elements of abstraction into her work, and certainly understood the power of expressionism. As art historian Roger Hull has noted, Fowler "sensed and expressed the turbulence and darkness of nature."

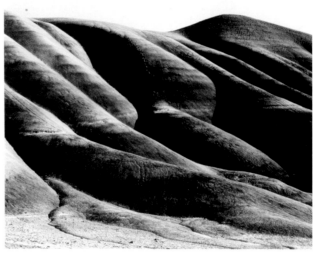

Bernard Freemesser (1926–1977)
Painted Hills, 1972
Gelatin silver print

Although he began his career as a photojournalist, Bernard Freemesser gradually moved to a large-format camera and to subject matter rooted in the landscape of Oregon and the American West. He was particularly influenced by the work of Brett Weston (a son of Edward Weston), and was noted for his extraordinary skills in printing. Painted Hills is a study of light and shadow, and of the geologic phenomenon that produces such giant folds in the earth's surface.

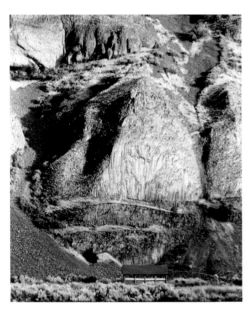

Bernard Freemesser (1926–1977)
Untitled, 1972
Gelatin silver print

Although he began his career as a photojournalist, Bernard Freemesser gradually moved to a large-format camera and to subject matter rooted in the landscape of Oregon and the American West. He was particularly influenced by the work of Brett Weston (a son of Edward Weston), and was noted for his extraordinary skills in printing. In this photograph, the sheer verticality of rocks and rock slides overwhelms the tiny evidence of human presence—a shed-roofed structure utterly dwarfed by its surroundings.

Christine Fry-Loftis
Long Island No. 11, ca. 1977
Charcoal or crayon on paper

In her drawing of underbrush, Christine Fry-Loftis suggests the high contrasts and glare of a black-and-white photograph, in which foreground details have been bleached out by sunlight and the shadows yield few details. The suppression of such individual elements as leaves and twigs, and the attention to linear elements, are evidence of the artist's skills as a draftsman, also visible in her many landscape prints.

Christine Fry-Loftis
Eagle Creek, 1978
Lithograph

As in her drawings, Christine Fry-Loftis suggests in this lithograph the contrasts of a photograph taken in brilliant light. The site of her image is Eagle Creek, one of the most spectacular spots in the Columbia River Gorge, known for its massive boulders and succession of waterfalls.

Heidi Fuhrmeister
Untitled, ca. 1976
Woven fiber

The 1970s were noted for a revival of interest in fiber arts, brought about by the feminist movement and by a new attention to crafts in general. Heidi Fuhrmeister's untitled weaving is a masterful blend of geometric precision and expressive use of color. Against the overall grid, reminiscent of the era's focus on minimalism, Furhmeister has juxtaposed a subtle gradation that suffuses each quadrant of her work with a gradual blush of color.

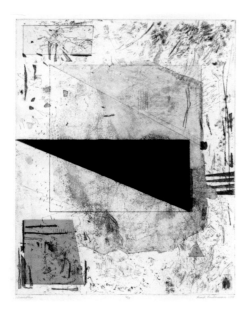

Sheryl Funkhouser
Ultramarine, 1978
Etching

Sheryl Funkhouser's distinctive style combines elements of abstraction with snippets of imagery gathered from myriad sources. Her resulting compositions have the quality of exquisitely crafted collages, in which each element not only carries its weight formally but also adds a sense of narrative content to the image as a whole. Funkhouser is rightly admired for her mastery of techniques. She is a graduate of the Pacific Northwest College of Art and was one of the original members of Portland's Blackfish Gallery.

Gordon W. Gilkey (1912–2000)
La Succession Terrestre III-IV, 1973
Etching

Famed as a collector, teacher and mentor, Gordon Gilkey was also a noted printmaker, one whose career began and ended in Oregon, where he spent many years teaching at Oregon State University before he became Curator of Prints and Drawings at the Portland Art Museum. A master of all printmaking processes, including, in his later years, photolithography, Gilkey returned frequently to the intaglio methods. With its painterly textures and gestural lines, this work is representative of Gilkey's interest in abstraction.

William Givler (1908–2000)
In the Woods, n.d.
Lithograph

William Givler's love of prints and printmaking defined both his life as an artist and his role as a teacher. He initiated the printmaking program at the Museum Art School (now the Pacific Northwest College of Art) in the 1930s and devoted much of his own artistic energy to lithographs. *In the Woods* exemplifies Givler's style and his love of the Oregon landscape, the subject of most of his prints and paintings.

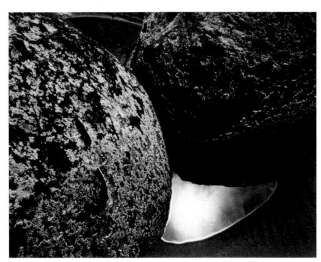

William H. Grand
Untitled, 1957
Gelatin silver print

William Grand's image exemplifies an aesthetic approach to photography developed by such artists as Harry Callahan and Minor White in the 1940s and 1950s. White sought to find "equivalents" through his camera —symbolic elements derived from the natural world, yet abstracted through his framing and composition. In Grand's image, it is the repetition of rounded shapes and the fan-shaped pool of water, with its glowing reflection of the sky, that give this photograph its transcendent qualities.

Jeff Goldner
Sable Connection, 1977
Toned gelatin silver print

From its cryptic title to its enigmatic visual elements, this dim interior space is suggestive of film noir. Who is the woman we glimpse through a doorway? What is the significance of the photograph and the glowing mirror? Why is a balloon resting on the quilt on the bed? Light sources are similarly mysterious. Goldner's cinematic touches anticipate the work of Cindy Sherman and other photographers who use the photograph to stage a narrative.

Don Gray
The Trailer, ca. 1976
Watercolor on paper

Eastern Oregon artist Don Gray is a masterful realist, whose work ranges from murals to still-life paintings and landscapes. With its meticulously observed details—the texture of the stubbly grass, the worn wood of the trailer—and dramatic contrasts of light and shadow, this watercolor painting is reminiscent of the work of Andrew Wyeth, who, like Gray, found larger realms in the everyday details of life.

George Green
Sea Train, ca. 1976
Acrylic on canvas

In the mid 1970s, George Green arrived at the subject matter for his distinctive paintings—what he has called "illusionistic abstractions"—by arranging strips of painted canvas and small paint-spattered bits of masking tape over a canvas support. Instead of focusing solely on their colors and geometric shapes, Green treated the banners as three-dimensional objects, complete with carefully rendered shadows that heighten the illusion of three-dimensionality. This is a technique that is best known by its French term, "trompe l'oeil," or "fools the eye." Green adds a new wrinkle to this ancient technique with his compositions, which are essentially abstract explorations of ways in which colors interact with each other.

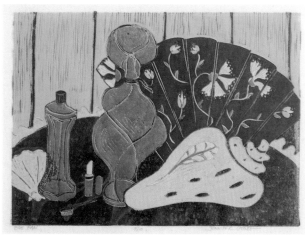

Jennifer Guske
Blue Fan, ca. 1976
Linoleum cut print

With its attention to patterns and clear colors, Jennifer Guske's tabletop still-life print suggests the vibrant simplicity of modern artists such as Henri Matisse. Working with strong lines and a variety of simple shapes, Guske creates an appealing composition. Guske is known for her work as a printmaker and has also designed ceramic tiles.

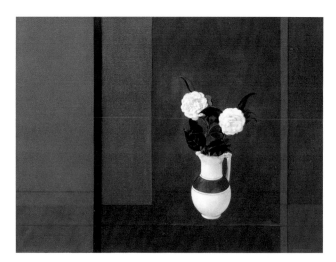

Sally Haley (1908–2007)
Camellias, n.d.
Acrylic on canvas

By isolating a vase of flowers and placing it in an abstract, vaguely architectural setting, Sally Haley creates an image that transcends the description "still life." *Camellias* has a quiet certitude, reminiscent of artists like Jan Vermeer, where simple objects attain a majestic beauty. Haley, who moved to Portland in 1947 with her husband, artist Michele Russo, was as interested in modern art movements as she was in old-master painting. Her sensitive understanding of art history is evident in works such as this.

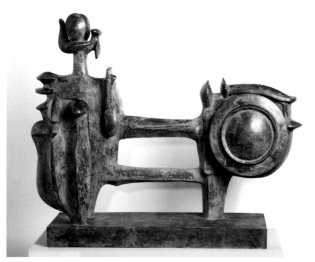

James Lee Hansen
Rattle Man Study II, 1971
Bronze

In the course of his long career, sculptor James Lee Hansen has focused on abstracted forms that draw connections back to elemental myths and the concept of opposing dualities. *Rattle Man Study II* references both human and animal forms and relates to a series of similar works he made in the 1970s, based on Native American imagery and myths. Hansen has also looked closely at Chinese bronze sculptures, and his exquisite patinas are testament to that study. Hansen, who taught sculpture at Portland State University for many years, maintains his own foundry.

Goodwin Harding
Kelp, ca. 1977
Gelatin silver print
1985 Acquisition

Since the 1970s, Goodwin Harding has been known for his exquisite landscape photography. He has become a master of the platinum and palladium methods—alternatives to the gelatin silver process—which yield rich and deep prints. *Kelp*, with its luminous surface and beautiful patterns, anticipates his later work. Harding, who has lived on the Oregon coast, photographs there and elsewhere in the West. He has been involved with the Sitka Center for Art and Ecology in Neskowin.

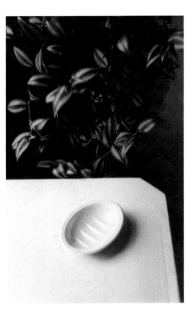

John Hawkes
Soap Dish, 1977
Gelatin silver print

John Hawkes finds quiet beauty in the simple details of an interior. Situating his camera above his subject matter, Hawkes creates an abstract composition of light and dark shapes and emphasizes a few subtle touches—for instance, the soft shadow cast by the soap dish, and the variegated leaves of the houseplant.

Stephen Hazel
Mindreader, ca. 1977
Intaglio

Although he is a painter and sculptor and was first trained as a ceramic artist, Stephen Hazel is known for his skills as a printmaker, moving effortlessly between lithography, woodcut prints and the intaglio processes. His imagery is based in abstraction and in the tension he creates through his use of diagonal lines that often, as here, define two forms that, while similar, are not identical. Hazel, who has worked and taught in France and Italy, has also studied in Japan.

Charles Heaney (1897–1981)
Genesis 1-20:1, n.d.
Plaster, paint

Charles Heaney's prints and paintings are informed by his love of the vast, spare landscapes of eastern Oregon and Nevada. *Genesis 1-20:1* is one of a series of explorations of abstracted fossil imagery created by Heaney. According to art historian Roger Hull: "In the 1940s, Heaney created mixed media "fossils," combining plaster relief, painting, carving, and imprints of actual fossils. He considered these irregularly shaped wall pieces to be his most original work."

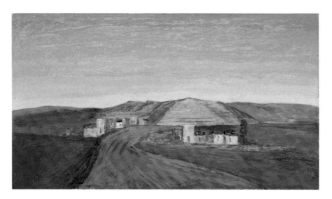

Charles Heaney (1897–1981)
The Settlement, n.d.
Oil on masonite

Charles Heaney's paintings are informed by his love of the vast, spare landscapes of eastern Oregon and Nevada. His minimalist compositions are constructed by placing together slabs of road, mesa, and enormous expanses of sky. He traveled to these sites as often as he could, and his paintings evoke a sense of places with which he was utterly familiar. Heaney studied at the Museum Art School (now the Pacific Northwest College of Art) and was also a gifted printmaker.

James Hibbard
Greenhouse, 1976
Etching (unfinished state)

James Hibbard is renowned for his virtuosity as a printmaker. With its myriad elements and lyrical forms, *Greenhouse* is evidence that his reputation is well deserved. Hibbard is Professor of Art Emeritus at Portland State University, where he taught for many years. He is also a founding member of Blackfish Gallery in Portland and the founder of Pyramid Press, now known as Piramidal Gráfico and located in Guanajuato, Mexico.

Craig Hickman
House/Tree, 1975
Gelatin silver print

Craig Hickman's photographs of the 1970s are investigations of his environment. Using his camera in a similar manner to such photographers as Lee Friedlander and Gary Winogrand, Hickman produced straightforward images of everyday phenomena—the solidity of branches and leaves dissolving in a blast of sunlight, the rather homely side of a brick building. The resulting images are not the stuff of "fine art" photography but are, in curator Terri Hopkins's term, "observational archeology."

Julia Hoffman (1856–1934)
Studio, ca. 1895
Gelatin silver print

Julia Hoffman took up photography as a young mother and photographed extensively between 1888 and 1904, when she put down her camera to pursue other activities. She was interested in all forms of art and also in the Arts and Crafts movement. Among her images are several of interiors. Her home at 714 Everett Street in Portland included this spacious studio, where she was able to pursue her painting and sculpture and where visiting artists often held classes.

Julia Hoffman (1856–1934)
Margery Hoffman (in L.P. Hollander Coat), ca. 1894
Gelatin silver print

One of the most important cultural figures in Portland, Julia Hoffman was both an artist and a patron of the arts; her early support helped bring into being what are now the Pacific Northwest College of Art and the Oregon College of Art & Craft. As a young mother, she took up the practice of photography, documenting the life and travels of her family and friends with sensitivity and, sometimes, a certain humor. In this image—is it a portrait of her daughter Margery or of the overwhelming coat and beribboned hat?—Hoffman shows her gift for subtle lighting.

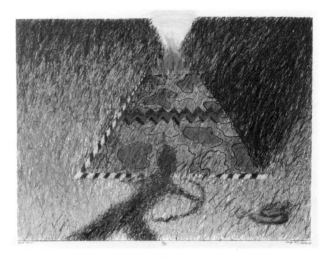

Michael Holmes
Red Fire, ca. 1976
Serigraph print

In this dreamlike image, the shadow of a figure with a bow looms against a teepee in the background. Volcanic smoke and fire erupt from its top, breaking out of the picture plane. By using a generic symbol like the teepee but subverting it with a band of rickrack, Holmes adds a new layer of meaning to this image and to its title, *Red Fire*.

William Hoppe
Untitled, ca. 1976
Acrylic on canvas

Over the years, Bill Hoppe's fascination with the relationship between musical and visual composition has informed many of his large, geometric abstractions. By restricting his palette and repertoire of forms, Hoppe creates patterns of color and shape that interlock, repeat and unfold. Hoppe's love of symmetry and geometry also extends to his format; he favors large works and often pairs two canvases to form a diptych.

Lawrence Hudetz
Eagle Creek, Columbia Gorge, 1977
Gelatin silver print

Lawrence Hudetz has been making photographs since the late 1950s, concentrating on the landscapes and buildings of the Pacific Northwest. He is known for his images of Timberline Lodge and of buildings designed by architect Pietro Belluschi. This photograph typifies Hudetz's mastery of composition and control of light. In a seemingly simple image, Hudetz captures the beauty of a trail in the Columbia River Gorge, where trees and shadows create a lacy pattern.

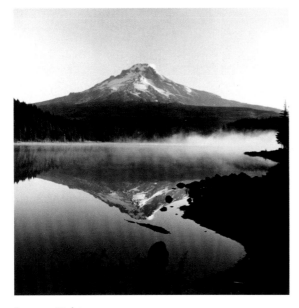

Lawrence Hudetz
Mountain, 1972
Gelatin silver print

Lawrence Hudetz is known for his love of the landscapes of the Pacific Northwest—the Columbia River Gorge, the forests and the mountains. In this image, Hudetz focuses on the iconic profile of Mount Hood as seen from the shores of Lost Lake. Placing his horizon line at the center of this photograph, Hudetz allows the mountain's reflection to dominate his composition. In recent years, Hudetz has worked extensively with digital technology and with color processes.

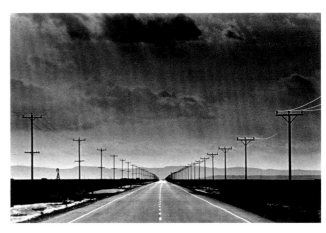

Howard Huff
U.S. 20, Burns, Oregon, 1944
Gelatin silver print

The views along U.S. 20, which runs through the center of Burns, have changed little since Howard Huff made this picture more than 60 years ago. Huff, who taught photography for many years at Boise State University, was attracted to the austere landscapes of eastern Oregon and Idaho. Here, he juxtaposes the regular rhythm of the two-lane highway and flanking telephone poles with the unpredictable drama of storm clouds and water-filled ditches.

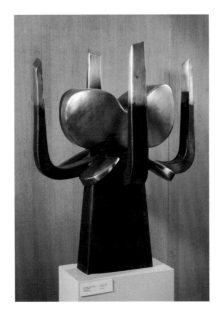

Manuel Izquierdo (1925–2009)
Moonblades, ca. 1976
Welded steel

With its beautifully burnished surfaces and slightly anthropomorphic forms, *Moonblades* is typical of Manuel Izquierdo's welded steel sculptures, which can be found in many collections on the West Coast. A consummate craftsman, Izquierdo was drawn to carving from his early childhood; his tour-de-force woodblock prints are also testament to his skills. Izquierdo, who was born in Spain, made his way to Oregon as a young boy. He attended the Museum Art School (now the Pacific Northwest College of Art) and taught there for many years.

Jay Jensen
Jasper, ca. 1976
Ceramic

The title of this piece—a shallow bowl with horizontal lines of glaze in blue and browns—references its similarity to a cross-section of the beautiful banded chalcedony known as jasper. Jay Jensen, who received his degree from the University of Hawaii, is known for the simplicity of his forms and his glazes.

George Johanson
Cat's Moon Dancer, 1975
Etching

Because he is fascinated by the span of art history, George Johanson's prints and paintings combine images drawn from his own life with multiple references to other artists, both past and present. Johanson, who attended the Museum Art School (now the Pacific Northwest College of Art) and taught there for many years, also spent time in New York and in London, where he became intimately familiar with abstract expressionism and with such British artists as Francis Bacon. Thus, one can find both figurative and abstract passages in a print such as *Cat's Moon Dancer*.

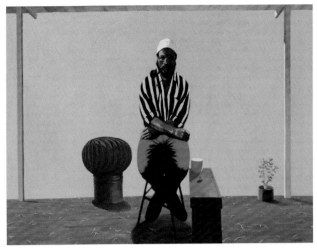

George Johanson
Manuel Izquierdo, 1977
Oil on canvas

George Johanson is known for prints and paintings in which he depicts his friends and family. His subject here is the late Manuel Izquierdo, with whom Johanson studied and taught for many years. Izquierdo, a frequent presence in Johanson's work, was known for his collection of hats and his ever-present pipe. This work, with its flattened forms, monochrome background, and cactus-like ventilation duct, is reminiscent of David Hockney's pop-era southern California portraits.

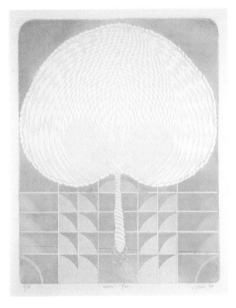

Liza Jones
Woven Fan, 1977
Etching

Taking the shape of a common fan as her starting point, Liza Jones builds a composition in which its curves become the backbone of a meditation on symmetry, lines and patterns. Jones, who lives in Manzanita, studied painting at the Rhode Island School of Design and printmaking at Portland State University. She is also known for her pastel drawings.

David Joyce (1946–2003)
Short People, 1986
Gelatin silver prints on masonite
1985 Commission

David Joyce's skills as a photographer and his sense of gentle whimsy are both evident in *Short People*, a work best described as "photographic sculpture." In this piece, as in many others, Joyce cut out life-sized photographic prints of his subjects, then assembled them, often with actual objects. The resulting works thus reference the photorealist movement of the 1960s and 1970s as well as the environmental sculptures of artists such as George Segal.

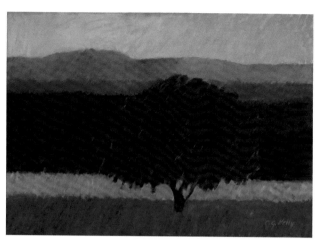

Charles Kelly
Landscape (Banded), ca. 1976
Oil on canvas

As much a study of colors as a landscape, Charles Kelly's composition might be an abstract study were it not for the flattened form of a tree that establishes the distance between foreground and background. Kelly subtly alters naturalistic colors—a band of pink for the sky and a deep blue for the hills closest to us—so that the painting, with its lively diagonal brush-strokes, is also expressionistic.

Louis Kimball
Untitled, 1975
Gelatin silver print

Beginning in the 1920s, a number of photographers in Europe and America made images of ordinary objects such as tools, hardware and implements. With its sharp focus and lack of context, Louis Kimball's print is in that tradition. In his photograph, we are drawn to the four tubes not for what they are, but because of the purity of their forms, the elegant curves of the shadows they cast, and the creamy white of their matte surfaces.

Louis Kimball
Untitled, 1975
Gelatin silver print

In this fascinating photograph, Louis Kimball dispenses with any references to scale, so that we have no idea what we are looking at. Is it a vast manu-facturing plant of some sort, or simply a tabletop arrangement of fabricated metal cones and tubes? Kimball is working here in the tradition of photog-raphers who, by removing objects from their context, force the viewer to consider their hitherto unrecognized aesthetic qualities.

Marian Wood Kolisch (1920–2008)
Portrait of Rachael Griffin, ca. 1976
Gelatin silver print
1985 Acquisition

Although she studied with the famed landscape photographer Ansel Adams, Marian Kolisch was drawn to portraiture. Over the course of her career, she photographed many of the notable figures of Portland, including Rachael Griffin, a longtime curator at the Portland Art Museum. Griffin's relaxed pose and half-smile are evidence of Kolisch's ability to establish rap-port with her subjects.

Marian Wood Kolisch (1920–2008)
Portrait of Ansel Adams, ca. 1975
Gelatin silver print
1985 Acquisition

Portland photographer Marian Wood Kolisch's portrait of her former teacher and mentor Ansel Adams is a study of textures as well as an insightful view of her subject. The soft felt of Adams's hat contrasts with his vigorous beard and the out-of-focus tree bark. Kolisch specialized in portraits of cultural leaders in Portland and elsewhere. She was a granddaughter of C.E.S. Wood, himself a prominent Portland citizen and, in his later years, a friend of Ansel Adams.

Henry (Hank) Kowert (1924–1977)
Sunrise, Mary Peak, n.d.
Watercolor on paper

Hank Kowert's short career unfolded in Oregon; he arrived in the state in the 1950s, having studied at Cranbrook Academy in Michigan. Kowert's abiding interest was in the landscape and in capturing light and atmosphere. *Sunrise, Mary Peak* shows Kowert's skill with watercolors, as he builds up the sturdy forms of rocks and trees, and, with delicate washes of color, suggests the stormy, light-strewn sky.

Henry (Hank) Kowert (1924–1977)
Dry Region, n.d.
Watercolor on paper

While he worked with oil paints and was a printmaker specializing in serigraphy, Hank Kowert was a master at watercolors. Using a muted palette—and the occasional glimpse of brilliant color—Kowert focused on the landscape. His interest was not so much in the specifics of a place as in revealing the mood of his location and capturing the effects of light and changing weather.

La Verne Krause (1924–1987)
Silver Snow Blues, 1975
Oil on canvas

By all accounts, La Verne Krause was an indefatigable artist, always sketching, painting, or making prints. Her earlier works focused on the human figure and on cityscapes, but as she became more influenced by American abstract artists of the 1950s, her love of color took over in free-form landscapes that can be riotous or, in the case of *Silver Snow Blues*, quieter and more reflective. Krause was a gifted teacher and her love of printmaking led her to establish the Northwest Print Council (now Print Arts Northwest).

Lorraine Krol
Down Commonwealth, ca. 1976
Lithograph

A study of patterns, Lorraine Krol's lithograph focuses on a quiet street of small, wood-frame houses, each slightly different from its neighbor. What gives this image its charm are the potato-shaped puffy clouds, growing smaller as they recede, and the regular, checkerboard lawns.

James Lavadour
Flag 2, 2001
Oil on panel
2010 Acquisition made possible by
The Ford Family Foundation Visual Arts Program

James Lavadour's paintings are influenced by the landscape of eastern Oregon, where he was born and raised, as well as by jazz and abstract expressionism. *Flag 2* represents an important transformation in Lavadour's work, as he began to layer more traditional landscape compositions with what he refers to as "architectural abstractions." This painting was purchased with funds provided by The Ford Family Foundation Visual Arts Program, established in memory of one of the Foundation's co-founders, Mrs. Hallie Ford. It is the first work collected through its Art Acquisition Program, which seeks to place seminal works by Oregon artists into publicly accessible collections.

Carolyn Lee
A Dance Fandango, 1977
Fiber bound with copper wire

As its title suggests, Carolyn Lee's fiber sculpture evokes the fandango, a fiery dance associated with flamenco. Her brilliant multicolor forms evoke heavy, swirling skirts and petticoats, and the passionate music that accompanies the performers. Lee's work can be seen in the context of the 1970s, when textile arts assumed a new importance and artists began to question and to challenge the boundaries between "art" and "craft."

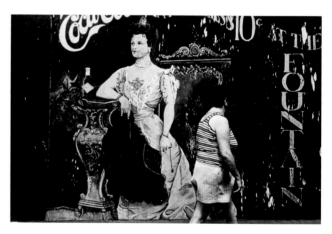

Steven Lewis
No. 5, Untitled, 1976
Gelatin silver print

Steven Lewis's humorous image juxtaposes an elegant, if somewhat faded Edwardian beauty advertising Coca Cola with a modern, sloppily dressed passerby. Although Lewis' subject is certainly not a "bum," this photograph calls to mind one of Andy Warhol's pronouncements about the equality of American consumerism: "A Coke is a Coke and no amount of money can get you a better Coke than the one the bum on the corner is drinking. All the Cokes are the same and all the Cokes are good."

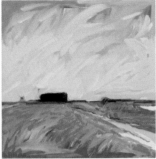

Nancy Lindburg
Dakotascape I and II, 2010
Oil on board
2010 Acquisition

Nancy Lindburg, a long-time Salem resident, was director of the Salem Art Association from 1973 to 1978, and became the visual arts coordinator for the Oregon Arts Commission in 1978, where she served until her retirement in 1981. Her painting has included significant work in abstraction and figuration as well as landscapes.

Lanny Little
Fifty-Six Studebaker, ca. 1975
Acrylic on canvas

Lanny Little's lovingly rendered portrait of a Studebaker is representative of the style known as photorealism. Beginning in the late 1960s, a number of artists sought to replicate the effects of amateur color photography, with its light flares and shifts in focus. Little, who received his MFA from the San Francisco Art Institute, has continued to make realist paintings and is known for his historical murals as well.

Susan G. Lloyd
Water Reflection, 1975
Gelatin silver print
1985 Acquisition

Although it is a straightforward image—two puddles in a gravel road—Susan Lloyd's image can also be read as surreal. The puddles, mirroring the stormy sky, become haunted eyes and the gravel suggests a brow and nose. Lloyd's photograph is reminiscent of the work of such artists as Minor White, who used the camera to record abstract elements that could be read as symbols of an intellectual or emotional state.

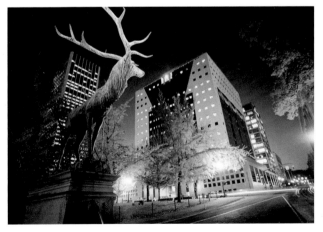

Jim Lommasson
Elk Fountain, 1982
Digital pigment print
2010 Acquisition

Jim Lommasson's documentary photographs weave visual stories of lives and histories as varied as the aftermath of Hurricane Katrina, the challenges faced by returning veterans, and the paintings that once decorated a carousel at Oaks Park. His book, *American Fight Clubs*, received The Dorothea Lange-Paul Taylor Prize from The Center for Documentary Studies. *Elk Fountain*, part of Lommasson's "Night Visions" series, captures a quintessential downtown Portland view in the rare emptiness of night.

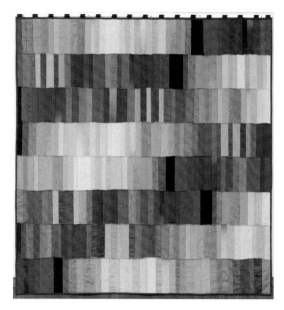

Marie Lyman (1950–2000)
Desert Grasses, 1977
Mixed-media textile

Marie Lyman was fascinated by the history of textiles, and was particularly knowledgeable about Japanese textile traditions, from folk crafts to courtly garments and embroideries. She was known for the refinement of her tapestries and other pieces. With its spare, geometric elegance and muted tonalities, *Desert Grasses* suggests an Asian, rather than an American aesthetic.

Russ Mahler
Venetian Blind, 1977
Serigraph

A study in line and texture, Russ Mahler's abstract image is also a fascinating blend of spontaneity and control. The scribbled surface is seemingly at odds with the regularity of the horizontal lines that emerge from its chaos. And the equilateral triangle, poised in the center of the composition, imposes its own order. Mahler, who studied printmaking at the Pacific Northwest College of Art, is now a graphic designer.

William Massey
Confetti Is Good for the Soul, 1978
Serigraph

Working with the silk-screen process that artists such as Robert Rauschenberg and Andy Warhol made so popular in the 1960s, William Massey animates his somber landscape with "confetti"—undulating strips of brilliant colors. Overlaid against the night sky and the dark foreground, they illuminate the composition as if they were fireworks.

Michael Mathers
Buckaroo, 1976
Gelatin silver print

Michael Mather's photograph can be seen as an occupational portrait, in which our understanding of the subject is enhanced by the details of costume and, especially, setting. The beat-up hat, well-worn boots, and rows of horseshoes certainly suggest the way this man makes his living. Mathers, who now focuses on architectural photography, spent several months researching the lives of sheepherders in the 1970s, when this photograph was made.

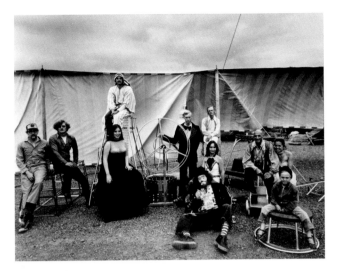

Michael Mathers
One Ring Circus, 1975
Gelatin silver print

Looking as if they have stumbled off the screen of a film by Federico Fellini, the eleven members of a traveling circus pose against a billowing striped canvas wall which offers no protection from the cloud-filled sky. In spite of the fact that they are captured off-duty, as it were, these performers, with their costumes and paraphernalia, retain a sense of the drama and exoticism of their profession.

Grayson Layne Mathews (1948–2007)
Near Christmas Valley, Oregon, 1976
Gelatin silver print

Grayson Mathews's images of the rural west were informed by his admiration of the photographers who worked for the Farm Security Administration during the 1930s, documenting the effects of the Dustbowl and Great Depression. Although it was made in the 1970s, this photograph captures a similar sense of the American West. The beat-up truck, the livestock in the distance, and the lonely butte on the horizon create an evocative and timeless composition.

Lyle Matoush
A View Through That Man's Land, ca. 1976
Intaglio

With its expressionist sense of gesture and spontaneity, Lyle Matoush's composition is typical of the works he made in the 1970s. Matoush, who taught at Southern Oregon University for many years, studied various printmaking processes, working in professional print shops and becoming a master lithographer. He was a founding member of the Northwest Print Council (now Print Arts Northwest). In recent years, Matoush has begun to explore the medium of pastels, inspired by the example of Edgar Degas.

Robbie McClaran
Barry Lopez, 1997
Digital pigment print
2010 Acquisition

A Portland-based freelance photographer, Robbie McClaran is known primarily for his documentary work, which has included environmental portraiture, landscapes and socially-based projects. His editorial work has been largely concerned with assembling a portrait of America through landscapes and people, including such well-known figures as Oregon author Barry Lopez, a winner of the National Book Award.

David McCosh (1903–1981)
Cascade Study #2, n.d.
Oil on canvas

Over the course of his long career, David McCosh moved from works best described as somber social realism to brilliant landscape paintings such as *Cascade Study #2*. With its emphasis on the relationship between figure and ground and its exploration of color, the composition is typical of McCosh's highly individual style—a style that shows his absorption of the lessons of such modern masters as Paul Cézanne but also his awareness of abstraction. McCosh, who taught at the University of Oregon from 1934 to 1972, maintained an active presence both in the Northwest and nationally.

Jack McLarty
Tracking, n.d.
Oil on canvas

Renowned as a painter and printmaker, Jack McLarty studied at the Museum Art School (now the Pacific Northwest College of Art), where he also taught from 1946 to 1981. He and his wife Barbara also ran the influential Image Gallery, which opened in 1961. Like other artists of the region, McLarty has maintained that working in the Pacific Northwest has given him the opportunity to develop his own voice and style without having to be concerned with the issues of a contemporary art market. With its odd juxtapositions, brilliant colors and mysteries, *Tracking* shows McLarty's fascination with an urban scene and with such historical art movements as surrealism.

Jack McLarty
Red Passage, 1976
Color Linocut

It is telling that *Red Passage*, one of Jack McLarty's best-known works, was included in an exhibition entitled "Art for People with More Taste Than Money," since McLarty has long championed the print as a democratic and affordable form of art. With its red-and-black palette and organizing grid, the composition presents the viewer with a taxonomy of related forms and images drawn from sources as varied as northwest coast Native American carving to urban street signs and the artist's own observations.

Earl Miller
California Flyer, 1975
Serigraph

Beginning in the 1960s, several American artists, such as Andy Warhol and Robert Rauschenberg, began experimenting with serigraphy, or screen-printing, a process long associated with commercial rather than fine art. By the 1970s, when Earl Miller made *California Flyer*, serigraphy had become a standard fine-art process. With its bold shapes, Miller's boldly colored abstract composition appears at first glance to be a collage assembled from pieces of overlapping paper.

Earl Miller
Stellar, 1976
Serigraph

Earl Miller's lively serigraph appears at first glance to be a collage assembled from shards of cut and torn paper. Much of the work's appeal comes from Miller's use of text—fragments of letter forms chosen not for their meaning but for their bold graphic strength and abstract power.

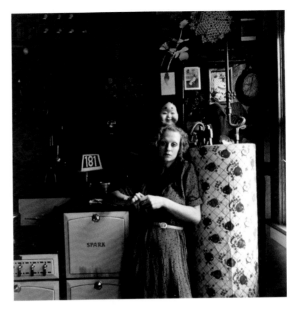

Robert B. Miller
Leigh Clark-Granville, 1979
Gelatin silver print
1985 Acquisition

In this image, Robert Miller explores the notion of the occupational portrait, a photograph in which the objects associated with a person suggest his or her profession. In a variation on that theme, actor Leigh Clark-Granville stands in a dimly lit space amid an assortment of cookery, toys and, most tellingly, a mask that, likeClark-Granville herself, looks directly at the camera, perhaps suggesting the performer's comedic side.

Alfred A. Monner (1909–1998)
Snowy Evening on Third Avenue, 1955
Gelatin silver print

Al Monner is known for his elegant photographs of the Oregon landscape as well as his images of the city of Portland and its citizens, from artists and cultural leaders to the many Roma (gypsy) people who once lived downtown. In this iconic image, Monner finds a gritty poetry in the texture of the falling snow, the reflections of muffled streetlights and the hurrying pedestrians, huddled against the damp cold air.

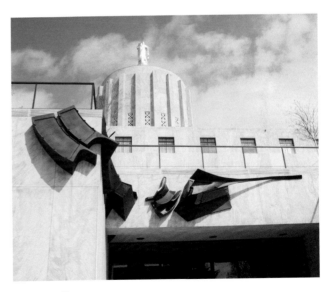

Tom Morandi
November Sprinter, 1976
Bronze

In describing the challenges of making this piece, sculptor Tom Morandi wrote, "Put simply, sculpture in its truest form is the control of space. Standard relief sculpture, with its elimination of all but one side, makes this extremely difficult. The solution, it seems, lies in developing forms that rely on the specific contours of the site ..." Morandi's other public commissions include both abstract and figurative sculpture, such as the installation *The Rest of Us*, at the Human Resources Building in Salem.

Hilda Morris (1911–1991)
Five Parts in Search of a Circle, 1969–70
Bronze

Among the themes that recurred in Hilda Morris's sculpture was the idea of the ring, a symbol of timelessness, unity and regeneration. She was also deeply influenced by the geologic forms of Oregon and Washington, where freestanding basalt columns mark the landscape. In this work, Morris pulls together these two powerful ideas in a composition that, while small in scale, is formidable in concept. Morris, who came to the Pacific Northwest in the 1930s, is also known for her eloquent, calligraphic sumi ink paintings.

Selina Roberts Ottum (1948–1990)
Edith Nelson, n.d.
Gelatin silver print

Although she is better known as a visionary arts leader, Selina Roberts Ottum studied photography at the University of Oregon. Her sensitivity and fine-tuned aesthetic are both visible in this portrait. Framing the figure beneath an arch of branches, Ottum captures both the tough and gentle sides of her subject. Nelson's rough plaid shirt contrasts with a wealth of silver jewelry, and her guarded expression is softened by her slight smile.

Henk Pander
Caryn and Colleen, n.d.
Pen and wash on paper

Born and educated in the Netherlands, Henk Pander is known for his portraits, still lifes and landscape paintings, as well as his exquisite large-scale drawings. *Caryn and Colleen* exemplifies his style, in which the artist works up certain areas of the composition with delicate cross-hatching and shading and uses line to indicate other objects and elements. Pander's works are often moody and ambiguous, with surreal overtones that suggest hidden tensions lurking just below the surface.

Lucinda Parker
Sky Horse, ca. 1975
Acrylic on canvas

Lucinda Parker's gestural and expressive paintings are based on the artist's profound understanding of the fundamental elements of art and design. And while she bases her works on observations of the natural world, Parker favors the abstract over the representational. *Sky Horse*, alive with vivid color and slashing strokes of paint, is also solid, with elements and colors that balance the riotous composition. Despite the fact that she studied art at a time when pop and minimalism predominated, Parker has maintained her commitment to the painterly surface.

Pam Patrie
Untitled, ca. 1976
Textile

Largely self-taught as a weaver, Pam Patrie has studied traditional tapestry techniques in France and is skilled in both historical and contemporary textile arts. Her work can be found in collections around the country. In this early weaving, Patrie references the landscape of Oregon, with undulating waves that suggest a cloudy sky, a mountain range, and foothills. But the piece can be also be read as an abstraction—a distillation rather than a depiction of place.

Ken Paul
Remnants of Landscape, 1975
Serigraph

When he made *Remnants of Landscape*, Ken Paul was in the middle of a series of prints that explored the conflict between the natural and the built environment. In his works of the time, Paul juxtaposed discordant imagery—a blocky, architectural form colliding with a distant landscape, for instance, to suggest the battle between the organic and the architectonic, the intuitive and the rational. Paul works in a variety of media, but is best known for his prints.

Michael Peterson
Live Oak River, ca. 1975
Photolithograph

In his image of a live oak tree, Michael Peterson suggests the richness and complexity of the natural world. The image is disorienting—it is difficult to know where we, the viewers, are positioned in relation to the picture plane. Are we above, looking down at a reflection in the river, or below, gazing up into a massive network of limbs and branches?

Michael Phillips
Aggressive Birth; Preparing for Flight, 1977
Lithograph

With its bold colors and shapes, Michael Phillip's lithograph has the quality of an expressionist painting. Phillips unbalances the symmetry of his composition with more randomly placed elements—blobs of white, diagonal lines—to add dynamic tension to the work.

Orleonok Pitkin
Mar, 1976
Litho-serigraph

Working in a minimalist style, Orleonok Pitkin explores the nuances of geometric forms and the ability of simple lines to suggest space and dimension. Pitkin also reveals his fascination with printmaking techniques; here, he has overlaid a lithograph with a screen print to add the patterns and lines that float on top of the darker ground. Pitkin, who is also a sculptor and painter, has long been interested in architectural forms and volumes.

Orleonok Pitkin
Arc Series #6, 1978
Serigraph

Combining hard-edged geometric shapes and lines with a soft palette, Orleonok Pitkin's *Arc Series #6* suggests the abstract paintings of Richard Diebenkorn's *Ocean Park Series*. And, like Diebenkorn's work, Pitkin's relies on his considerable drawing skills and his sensitivity to the ways in which colors interact with each other. An Oregon native, Pitkin attended the Pacific Northwest College of Art and has taught there for many years.

Jack Portland
No Nookies, ca. 1975
Tempera, mixed media on paper

Over the years, Jack Portland has built his own distinctive style, combining geometric abstraction and pattern with landscape and architectural elements. In this early work, elements of that style can be found in the symmetry of the composition, the repeating elements—triangles, rectangles and x's and o's. Still to appear are the rainbow colors that distinguish Portland's later paintings.

Jack Portland
This Guy Says..., 1976
Mixed media on board

Over the years, Jack Portland has formulated his own distinctive and poetic style, one that combines his love of early art and of pattern with his observations of landscape and architecture. The resulting paintings have a sense of both fantasy and structure, as if combining Byzantine mosaics with the work of Paul Klee. Portland, who attended the Pacific Northwest College of Art, has also studied in Italy, where he spends part of each year devoted to fresco painting.

Tom Prochaska
Home After the Rain, 2009
Oil on panel
2010 Acquisition

Tom Prochaska received his MFA from Pratt Institute in 1970. Since 1988, Prochaska has taught at the Pacific Northwest College of Art. Renowned as a printmaker and painter, Prochaska often paints *en plein air* at favorite sites such as Sauvie Island on the edge of Portland. The resulting works—impressionistic studies of light and color—reveal what the artist describes as a little visual miracle.

Tom Prochaska
Sauvie Island I, 2009
Oil on panel
2010 Acquisition

Tom Prochaska received his MFA from Pratt Institute in 1970. Since 1988, Prochaska has taught at the Pacific Northwest College of Art. Known both for his prints and his paintings, Prochaska often works *en plein air* at favorite sites such as Sauvie Island on the edge of Portland, the location for this work.

Kathleen Rabel
Calgary, 1976
Intaglio

Internationally known as a printmaker, painter, and sculptor, Kathleen Rabel is also a co-founder of +=studio blu=+, a print atelier in Seattle. Rabel studied at the University of Washington and has worked extensively in Portugal and Italy. Her compositions range from figurative subjects to abstract imagery. In the simplicity of this print, Rabel reveals the nuances of tonalities and of line. Note the exquisite irregularities that add tension and a sense of drama to the minimalist rectangle.

Christopher Rauschenberg
Untitled, 1973
Gelatin silver print

Over the years, Christopher Rauschenberg's fascination with the odd poetries of everyday existence has led to photographs made in old houses, in antique stores and flea markets, and on his travels around the globe. He is also adept at making light a palpable substance. In this early work, Rauschenberg's lens creates an uncanny image out of ordinary materials: a photographic portrait against a white wall, and a flare of light that dissolves the edge of a white door. Rauschenberg is a co-founder and director of Blue Sky Gallery in Portland.

Kim C. Raw
Landscape/Hills, 1977
Gelatin silver print

In Kim Raw's quiet landscape, the viewer's eye traverses a series of hills, drawn by the diagonal of a fence line that disappears as it snakes behind the horizon. No animals or buildings disturb this silent space, making the fence even more of an intrusion on the natural world.

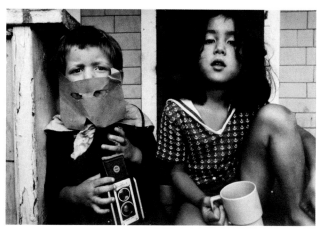

Cheryl Reed
Destiny Afternoon, 1976
Gelatin silver print

In this engaging image, two small children confront the photographer's lens with solemn curiosity. *Destiny Afternoon* is not quite a portrait, nor is it a candid image, but its uncontrived honesty captures the details of childhood in a photograph that is both straightforward and unsentimental, in a style that borrows from the snapshot aesthetic that marked the street photography of the 1960s and 1970s.

Bill Ritchie
The Little Spaceship Crash, ca. 1976
Intaglio print

Bill Ritchie's prints frequently mix humor with exquisite technique, as in this image—commemorative postage stamps rest atop a map of an unknown location, where topographical lines delineate a hilly terrain. Ritchie, who began his career as a printmaker in the 1960s, is known for his experiments with techniques and equipment, including small-scale etching presses he builds himself.

Gerald H. Robinson
Untitled (Nude), 1965
Gelatin silver print

Beginning in 1959 and continuing through the following decade, Portland attorney Gerard Robinson studied with Minor White, one of the preeminent photographers of the 20th century. Robinson and a group of other artists formed what they called the Interim Workshop, meeting to critique their prints between White's annual visits. In this classical study of the human form, Robinson positions himself firmly in the tradition of such figures as White, Imogen Cunningham, and others who found abstract beauty in the curves, angles and concavities of the body.

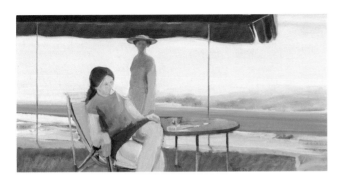

John Rock (1919–1993)
The Canopy, 1974
Oil on canvas

Better known as a printmaker, John Rock was also a gifted painter, moving easily between the two media. In *The Canopy*, his loose, expressive brushwork defines the forms of the two women in the foreground, and the distant landscape seen on the other side of an expanse of brilliant blue water. The shadow cast by the canopy adds a note of moodiness to the painting.

John Rock (1919–1993)
Landscape Composition in Monochrome Envisioned from La Coruña to Mousehold Heath, ca. 1975
Intaglio

Master printmaker John Rock taught at Oregon State from 1957 to 1989, and was best known for his skillful use of the intaglio processes. The title of this piece alludes to the seaport of La Coruña, in northern Spain, and to Mousehold Heath in Norwich, England, a favorite site for landscape painters in the 19th century.

Joan Stuart Ross
Three Magic Wands II, 1978
Intaglio

Joan Stuart Ross's fascination with color and line manifests itself in both her paintings and her prints. Ross cites influences as diverse as ancient Roman painting and the color theories of Josef Albers, with whom she studied at Yale University. She recently wrote, "My work in encaustic, oil, and print, layers up and digs down to find a hidden path to meaning. Repetitive shapes and marks cross the surfaces like shorthand messages; they cover what lies underneath."

Laura Ross-Paul
Second Creek, 2008
Oil and wax on canvas
2010 Acquisition

Over a painting career spanning three decades, Laura Ross-Paul has established herself as one of the preeminent Northwest painters. Her work is tied to our region's art history, taking early inspiration from the paintings of such artists as Mark Tobey, Kenneth Callahan and Morris Graves. She is also deeply attuned to the Northwest landscape, whose light and color informs her colorful and often mysterious narratives. Ross-Paul attended Oregon State University and received an MFA in Painting from Portland State University.

Jeff Rowe
Baker, Oregon, 1975
Gelatin silver print

In this spare image, Jeff Rowe juxtaposes two skeletal forms—a piece of dark, dried earth whose cracks mimic the twigs and spine of a fallen chalk-white weed. The photograph gains its drama from its high contrast and from its symbolic allusions to mortality. Rowe, who studied photography at the University of Oregon, has focused on landscape photography throughout his career.

Albert C. Runquist (1894–1971)
Oregon Landscape, n.d.
Oil on masonite

With its vibrant colors and brushy style, *Oregon Landscape* is typical of Albert Runquist's lively and expressive paintings of the Pacific Northwest, where he spent nearly all his life. Runquist worked on murals for the government-sponsored Works Progress Administration during the 1930s, was employed as a shipbuilder during World War II, and later moved to the Oregon coast with his brother and fellow artist Arthur. Runquist was a *plein-air* painter. As he noted, "Nature does not sit still to have her portrait painted."

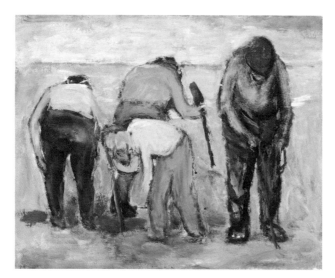

Arthur Runquist (1891–1971)
Clam Diggers, n.d.
Oil on panel

Before moving to the Oregon coast in 1945, Arthur Runquist, together with his brother and fellow artist Albert, spent three years in the shipyards of Vancouver, Washington. Arthur, in particular, made several paintings of the workers and activities there, and his interest in the figure continued in later years. In this painting, Runquist's minimal palette and blocky, simplified forms convey a sense of this familiar beach scene.

Arthur Runquist (1891–1971)
Beach Stumps, n.d.
Oil on panel

Arthur and Albert Runquist are among the best known of Oregon's mid-20th century artists. Like C.S. Price and Charles Heaney, their work is a response both to modernist ideas and to the social realism of the Depression. The brothers lived at Neahkahnie on the Oregon coast from 1946 to 1963, and much of their work is associated with this period. In *Beach Stumps*, Runquist finds eloquence and beauty in a weathered, waterlogged stump. His rich palette of silvery grays and black suggests the stormy drama of the coast.

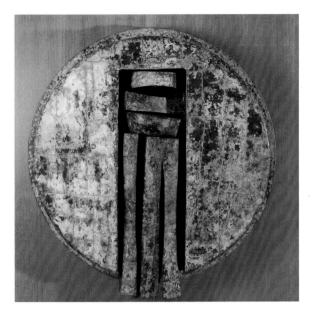

Melvin Schuler
Round Form, 1977
Copper over wood

Like an ancient shield or standard, Mel Schuler's wall-mounted sculpture is rich with patina and the marks of time. Schuler makes his distinctive sculptures with "shingles" of copper, overlaid and fixed to a carved wood base with brass nails. He taught at Humboldt State University for many years, received his MFA from the California College of Arts and Crafts in Oakland, and also studied sculpture at the Royal Academy of Fine Arts in Copenhagen, Denmark.

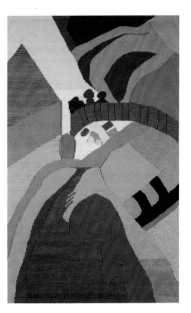

Christina Sells
And Out It Came, ca. 1977
Textile

With its range of colors and softened shapes, Christina Sells's tapestry suggests early modernist forays into the realm of abstraction. By holding on to recognizable imagery—the shape of a house, a suggestion of a tree and a fence—Sells creates a composition that functions both as landscape and as a tightly constructed exploration of the properties of shape and color.

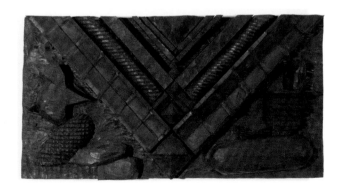

LeRoy Setziol (1916–2005)
Untitled, n.d.
Carved wood
2010 Acquisition

Recognized as the most accomplished and respected wood sculptor in the Northwest, Philadelphia-born LeRoy Setziol moved to Portland soon after World War II. Long admired by the architectural community, his carvings, richly textured and patterned, have been commissioned for public libraries and hospitals throughout Oregon and beyond. His work can also be found in Salishan Lodge and Timberline Lodge.

Evelyn Sheehan
Broken Echo, n.d.
Tempera on paper

Evelyn Sheehan, who studied art at UCLA and at Scripps College in California, has always been drawn to working on paper. She is best known for her watercolors, which range in style and subject from figurative studies to abstract compositions. Sheehan also explores collage, pastels, and acrylic media. Her work is represented in various local collections, both public and private.

Ken Shores
Fetish #13-4, n.d.
Mixed media

Although he trained as a traditional potter, Ken Shores's interest in the material of clay has always tended toward the sculptural rather than the functional. His studies, and his travels to India, South America, Thailand, and Morocco have exposed him to aesthetic traditions quite different from those of Western culture. A trip to Peru in 1968 inspired the series of pieces to which *Fetish #13-4* belongs. In these works, Shores unifies disparate materials—particularly feathers—with glazed clay, then seals them in mirror-backed Plexiglas boxes, further emphasizing their rarified, ritualistic nature.

Jim Shull
Condon Territory, 1976
Acrylic on canvas

Jim Shull's love of the Oregon landscape and its variety has led him to paint all over the state, from the coastline to the spare vistas of central and eastern Oregon. With its simplified lines and sense of vast space and geologic land-forms, *Condon Territory* is reminiscent of the paintings of Charles Heaney who, like Shull, was drawn to the hills and buttes of eastern Oregon. Shull received his MFA from the University of Oregon and, in addition to painting, has worked in graphic design.

Douglas Campbell Smith
North Fork, Green Water, 1977
Oil on canvas

Brilliant, high-key colors and lively brushwork are trademarks of Douglas Campbell Smith's appealing and accessible landscapes. This painting gains its particular impact from its large scale and from its composition, which emphasizes the strength of the water's flow, as well as the shafts of light that illuminate its surface and the faces of the boulders along the rocky shore. Smith, who taught for many years at Central Oregon Community College, is also known for his paintings of the French countryside.

Ron Sommer
A Falling of Dreams, ca. 1977
Lithograph

Since the development of lithography in the late 18th century, artists have valued the technique for its ability to convey the spontaneity of drawing as well as intense tonalities. In this print, Ron Sommer uses dense blacks as the basis for his composition, in which fantastical shapes appear as silhou-ettes against a storm sky.

Craig Spilman
Metallic Entry, 1975
Etching

In this composition, Craig Spilman demonstrates his skills as a draftsman and a printmaker. Essentially an abstraction, the imagery of *Metallic Entry* also suggests some sort of portal with a night sky looming in the background. In his more recent work, Spilman has turned to the landscape of the Willamette Valley, which he captures in ink drawings and monoprints.

Jerry Steiner
Rocks, South Coast (Pistol River), ca. 1985
Gelatin silver print
1985 Acquisition

The Oregon coastline near Pistol River is known for its sand dunes and for the number of freestanding rocks that rise up out of the waves and the sand. In Jerry Steiner's moody photograph, these megaliths seem almost animated, as if they were moving toward the horizon line across uneven waves of sand.

Michael Sumner
Piece for Wind, 1975
Etching

Michael Sumner's career has encompassed printmaking, drawing, graphic design, book publishing and video. *Piece for Wind*, with its imagery of musical notations, alludes to a score composed by nature, by the random noises and motions of the wind. It is likely that Sumner made this work with an awareness of John Cage's music, which also frequently incorporated elements of chance and ambient noise in composition and performance.

Virgil Sweeden
Barn, 1975
Gelatin silver print

Virgil Sweeden first picked up a camera when he was a child and was instantly entranced with how he could use photography to see the world. He earned his MFA from the University of Oregon and has been a commercial photographer ever since. An early work, *Barn* is a study of textures—weathered shingles, bare boards, sinuous blades of grass. But Sweeden has also made a fascinating horizontal composition, one in which the sag of the roof is perfectly matched by the dip in the grasses below.

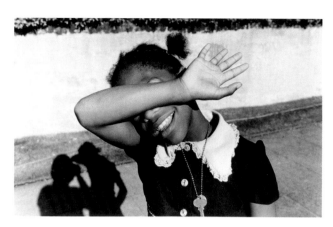

Stewart Tilger
Untitled, No. 2, n.d.
Gelatin silver print

Neither a portrait nor a spontaneous image, this photograph is fascinating because of its content and ambiguity. Is the young girl who looks up at the photographer covering her eyes because of sunlight, because of shyness, or because Tilger has asked her to assume that pose? And what is the subject of this image—the girl herself, or the shadows where her interaction with the photographer becomes a dramatic element in the narrative?

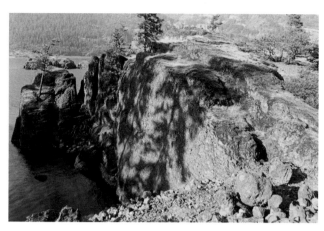

Terry Toedtemeier (1947–2008)
Faulted Outcrop, 1 mile west, Viento, OR, 1984
Gelatin silver print
2010 Acquisition

Terry Toedtemeier was the first curator of photography for the Portland Art Museum, a position he held until his death in 2008. His work focused on the geologic terrain of Oregon and the Northwest and several of his most important images are of sites in the Columbia River Gorge. Said the artist, "Though I have photographed geologically related terrains in Scotland and Hawaii, my goal is to create a body of work inspired by the place I've had the good fortune to have been born and raised in."

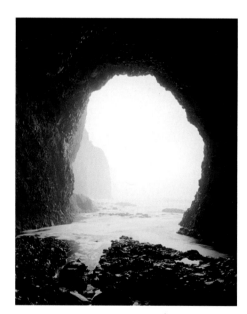

Terry Toedtemeier (1947–2008)
Fog at Entrance to Sea Cavern, Cape Mears, OR, 2001
Gelatin silver print
2010 Acquisition

Terry Toedtemeier was the first curator of photography for the Portland Art Museum, a position he held until his death in 2008. Toedtemeier received his degree in geology from Oregon State University, and focused his attention on a photographic record of the geologic terrain of the Northwest. This work is part of his study of the Oregon coast, made during extreme minus tides which allowed him brief access to sea caves and other usually submerged locations. Toedtemeier left behind, in his masterful photographs, an intricate map of views, from rare to iconic, of Oregon.

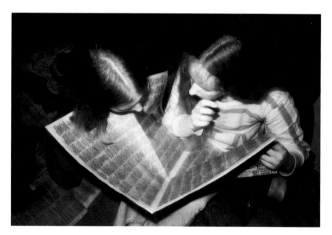

Terry Toedtemeier (1947–2008)
Newspaper, 1975
Gelatin silver print

In the early 1970s, before he turned to landscape photography, Terry Toedtemeier experimented with infrared film, drawn by its ability to capture and interpret spontaneous gestures and situations, particularly in low-light situations. In *Newspaper*, as in his other infrared work, Toedtemeier used his friends and family as subjects. The work gains its appeal from the discrepancy between the ordinary nature of the subject and the dramatic, often eerie effects of light.

Claire Trotter
Untitled, 1971
Gelatin silver print

Claire Trotter's minimalist photographs have been described as "a kind of visual haiku." Like that poetic form, Trotter's compositions contain few elements. Their studied and careful arrangement—the wind-rippled sand in the foreground, the elegant, spiky lines of the blackened plant, and the undulating curves of the sand dune—suggest larger vistas and the passage of time.

Phil Tyler
Bringing Up the Team, 1975
Watercolor on paper

Phil Tyler has specialized in scenes of the American West that, while nostalgic, are based on personal experience. He has prospected for gold in Alaska; hiked in the Sierras and the Cascade Range; ranched; and worked as a chuck-wagon cook and a wrangler in California and Oregon. Tyler studied and then taught painting and photography, and his work has been exhibited widely in the western United States.

Bill Wagner
Boats, 1976
Gelatin silver print

Bill Wagner's photograph is a study in symmetry and geometry, where strong vertical and diagonal lines define an almost abstract composition. But Wagner also focuses on atmosphere, particularly on the shoreline to the right, where blurred outlines stand in contrast to the crisp architecture of the boat.

Bruce West
Untitled, ca. 1975
Chrome-plated steel

In both his large- and small-scale sculptures, Bruce West evidences his sheer love of the properties of metal and his joy in finding inspiration from what he has called "the patterns and rhythms I see in the everyday world around me." While its grid pattern may reference minimalist works of the 1960s and 1970s, West has remained largely independent as an artist. West graduated from the University of Oregon and taught for many years at Lewis and Clark College. His works can be found in public collections and spaces around the Northwest.

Brett Weston (1911–1993)
Driftwood, n.d.
Gelatin silver print

In this photograph, Brett Weston focuses on the limbs of a piece of drift-wood, sprawling on the beach as it were a human body. Weston, like his father Edward, is considered among the most influential and important artists of the 20th century. He began making photographs when he was 13, and, like his father, favored a large-format camera. Driftwood is typical of his later work, when he tended to move close to his subject, eliminating the horizon line and other spatial references.

Edward Weston (1886–1958)
Fog, Oregon Coast, 1939
Gelatin silver print

Edward Weston photographed the Oregon coast as part of a project made possible with funding from his second Guggenheim Fellowship. This photograph encapsulates many of the qualities that make his landscapes among the most elegant ever made of the American West. Rocks, sunlight, fog, tide and driftwood are here woven into an image that is straightforward, yet mysterious. Weston was a founder of Group f/64, whose members emphasized sharp focus and images that were not manipulated in any way.

Minor White (1908–1976)
Portland's SW Front Ave, 1940
Gelatin silver print

In 1938, the Works Progress Administration hired Minor White to document Portland's waterfront and its iron façade buildings before they were demolished. This print is one of many that capture the elaborate 19th century buildings and streetcar lines. But, with its emphasis on dramatic sky and brooding light, the photograph hints at the direction White would take in his future work. After leaving Portland for the East Coast in 1945, White would become increasingly interested in incorporating abstraction and spirituality into his sharply observed images of architecture and the natural world.

John Whitehill-Ward
Offset, ca. 1976
Serigraph

John Whitehill-Ward is known as an artist and an educator, with a particular focus on graphic design and experimental printmaking techniques. In the 1970s, when this print was made, Whitehill-Ward was working with a large offset press, hence the title of this piece. Ward, who studied at the Maryland Institute of Art and the Illinois Institute of Technology, taught graphic design for many years at the University of Washington; he is currently an emeritus faculty member there.

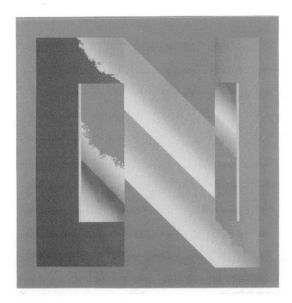

John Whitehill-Ward
Obelus, ca. 1976
Serigraph

The word "obelus" refers to the symbol that has been used in mathematical calculations since the 1600s for the division sign. The title is a fitting one for this print, which explores both colors and divided shapes. John Whitehill-Ward is a graphic designer who has written and taught extensively on color theory.

Harry Widman
Rug Invention Series, ca. 1975
Oil on canvas

Harry Widman, who taught for many years at the Pacific Northwest College of Art, is known for his unerring instincts about color and spatial relationships. He has long been interested in exploring myth and formal issues in painting using a vocabulary of forms and images developed and refined over years of thought. Widman painted *Rug Invention Series* at the beginning of his work on the theme of the magician and the magic carpet. In this early painting, he organizes his symbolic elements within a carpet-like grid; later variations dispensed with this rigid structure.

Shedrick Williams
Vase Still Life, 1974
Gelatin silver print

The intensity of Shedrick Williams's photograph stems from the sheer amount of visual information he has packed into the frame. The vase of flowers, centered in the composition, makes this corner of a barbershop into a de facto shrine. Even mundane objects—scissors, a tin of Alka Seltzer, a calendar from the Golden Dragon Restaurant—assume a ritual significance, as if they were votive offerings.

Robert Wilson
Milkcans, n.d.
Silver gelatin print

An active photographer based in Portland in the 1970s, little is documented of Robert Wilson's life or career. Photographed and printed with the utmost attention to a variety of surface textures and lines, *Milkcans* is reminiscent of a drawing on paper.

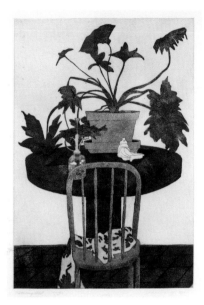

Sherrie Wolf
Gathering Dust, 1978
Etching

Although she has received much acclaim for her paintings in recent years, Sherrie Wolf is also a printmaker, who received her MA in printmaking from London's Chelsea College of Art. The subject of the still life, its history and meaning have been a constant source of inspiration for Wolf, and one she has treated in both her prints and paintings over the years. With its melancholy title and haunting imagery, this etching suggests the passage of time—the idea of the *memento mori*, or reminder of mortality, that is a central motif in historical still life compositions.

Christy Wyckoff
Contrail and Owyhee Summer, 1971
Color lithograph

Christy Wyckoff grew up in eastern Oregon, and has always been drawn to its open, spare landscape and vast skies. In prints such as this one, Wyckoff alludes both to the scene at hand and to the natural forces that formed the ridges and draws covered in the golden stubble of summer. Wyckoff has explored nearly every form of printmaking but considers lithography his favorite process. He received his MFA in printmaking from the University of Washington and has taught for several years at the Pacific Northwest College of Art.

Janet Yang
Illiana: Hawaiian Evening, ca. 1975
Etching

Seattle artist Janet Yang is known both for her interest in traditional Asian printmaking techniques, such as woodblock, and for her embrace of computer technology. This elegant composition, with its vertical format and calligraphic shapes, is suggestive of Chinese landscape painting.

Jan Zach (1914–1986)
Drapery of Memory, n.d.
Wood

Born in what was formerly Czechoslovakia, Jan Zach's travels brought him from Nazi Europe through South America and Canada and finally to the University of Oregon, where he taught sculpture for some years. He worked in metals, both cast and assembled, but the landscape and massive trees of the Pacific Northwest awakened in him an interest in wood. *Drapery of Memory* is one of many large-scale and expressive wooden sculptures Zach completed.

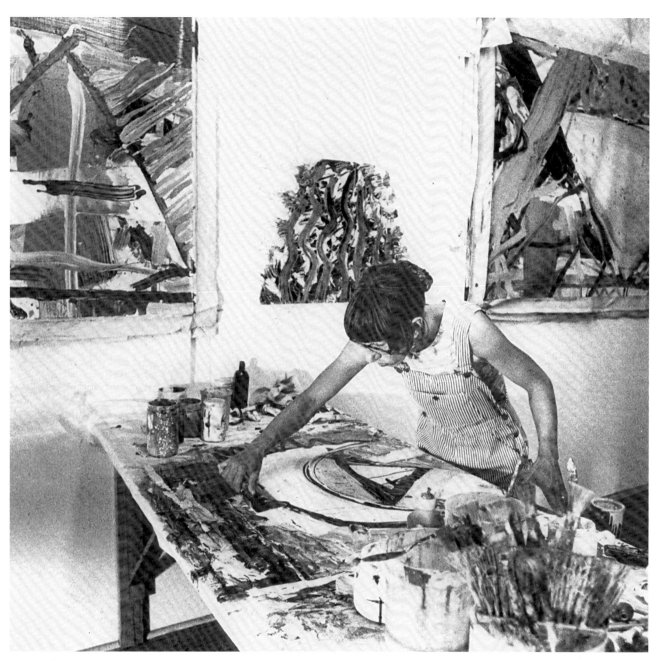

FIGURE 16.
Artist Lucinda Parker in her studio, circa late 1970s.
Photo courtesy Arlene Schnitzer/Fountain Gallery.

Art in the Capitol

State Street

First Floor

Areas where art is displayed are indicated in blue.

Legislative Counsel S-101 · Hearing Room A · Hearing Room B · Hearing Room C · Hearing Room D · Hearing Room E · Hearing Room F · Legislative Fiscal H-178

Galleria · Galleria · Tel · W M U

Visitor's Information · Visitor Services · Gift Shop · Men ADA · Women ADA

Tel · W · M · Rotunda · W · M · Tel

ADA Entrance

Second Floor

Senate Member Offices · Senate President's Office S-201 · U W M · House Democratic Office H-295 · House Member Offices · W M U · Conf. Rm. H-278

Senate Member Offices · Chief Clerk Office H-271 · House Member Offices

Governor's Reception 250

231 · Secretary of the Senate 233 · Senate · Rotunda · House of Representatives · House Speaker Office 269

W · M · W · M

Meeting Room 243 · Meeting Room 257

Third Floor

Conf. Rm. S-313A · Senate Member Offices · U W M · House Republican Office H-395 · House Member Offices · W M U

Senate Member Offices · Senate Republican Office S-323 · Room S-326 · House Member Offices

W · M · ADA · M

W M · Senate Gallery · Rotunda · House Gallery · W

335B

Fourth Floor

Senate Member Offices · U W M · House Member Offices · W M U

Senate Member Offices · House Member Offices

W · M

M · W · Rotunda · M

Adams, Ansel, *Cape Sebastian* — H3
Aldridge, Wayne, *Cows* — S3
Allara, Maxwell F., *Shell* — S2
Allen, Bonnie, *Contemplation* — S3
Alps, Glen, *Color Modification* — H1
Atkeson, Ray, *Sheep Pastoral* — H2
Backstrand, Jay, *Untitled* — S3
Baer, Morley, *Humbug Mountain, Oregon Coast* — H1
Bailey, Mark, *Rubber Forms* — H4
Bauguess, John, *Oregon Old Time Fiddler (Series)* — H3
Bayles, David, *Bandon Beach* — S3
Bencze, Lazlo, *Steelworker* — H4
Bloch, Ernest, *Self-Portrait* — H3
Bondarowicz, Marv, *Untitled (Nude)* — H2
Borch, Albert, *Untitled* — S4
Boyden, Frank, *Untitled Vase* — H2
Bratt, Byron H., *The Kiss* — S2
Bratt, Byron H., *The Witness* — S4
Britt, Peter, *Mollie Britt In The Parlor* — H3
Bromberg, Nikki, *Sherwood Attic* — H4
Brookes, Drex, *Still Life, Vase* — S3
Brophy, Michael, *Rising of the Moon 2* — H4
Bunce, Louis, *Midway #5* — 1 State Street Entrance
Burgess, James, *Grainery Stacks, Oregon* — S4
Burns, Michael, *Dormer* — H2
Carey, Owen, *Main Street, Wasco* — S4
Carpenter, Ed, *Untitled* — 1 State Street East Entrance
Carrasco, Priscilla, *Farm Labor–Day Haul To Salem* — H3
Carrasco, Priscilla, *Ungers Farm Labor Camp* — H4
Carver, George T., *Maupin, Oregon No. 2* — H2
Caulley, Pamela Powell, *Tulip, Stayton* — H4
Chen-Blakely, Karen, *Rain Water And Tusche Dried* — S3
Cloutier, James, *New American Gothic* — H3
Coates, James, *A Water Pipe Dream Or Is It?* — H2
Coe, Margaret, *Crater Lake 2* — H3
Cox, Dennis, *Menagerie* — H4
Cox, Duane, *The Ocean Floor* — S2
Crouch, Steve, *Salt Creek Falls* — H2
Cruson, Jon Jay, *View From The Studio* — H4
Cruson, Jon Jay, *Vista 14* — S2
Curtis, Edward S., *Dip-Netting In Pools, Wishram* — S2
Curtis, Edward S., *The Fish Carrier, Wishram* — S2
Dean, Bruce Goring, *Lois #2* — H3
Deknatel, Drake, *Aerial* — H2
Di Franco, Robert, *Untitled, Eunice's Porch* — H2
Di Franco, Robert, *Sabines Revisited* — S2
Erceg, Joe, *Grapes* — S2
Erceg, Joe, *Door/Reflection* — S4
Fawkes, Judith Poxson, *Untitled* — 1 HR B
Fawkes, Tom, *The Boathouse At Fresh Breeze* — 1 State Street West Entrance
Feves, Betty, *Garden Wall* — 1 State Street Entrance
Foss, Marilyn, *Dunes And Pussywillows* — S3
Fowler, Constance, *Oregon Clam Diggers* — S4
Freemesser, Bernard, *Painted Hills* — H4
Freemesser, Bernard, *Untitled* — H4
Fry-Loftis, Christine, *Long Island No. 11* — S2
Fry-Loftis, Christine, *Eagle Creek* — S2
Fuhrmeister, Heidi, *Untitled* — 1 HR C
Funkhouser, Sheryl, *Ultramarine* — S3
Gilkey, Gordon W., *La Succession Terrestre III-IV* — S2
Givler, William, *In The Woods* — S1
Goldner, Jeff, *Sable Connection* — S4
Grand, William H., *Untitled* — H4
Gray, Don, *The Trailer* — S4
Green, George, *Sea Train* — 1 HR D
Guske, Jennifer, *Blue Fan* — S2
Haley, Sally, *Camellias* — S1
Hansen, James Lee, *Rattle Man Study II* — H1
Harding, Goodwin, *Kelp* — H1

Hawkes, John, *Soap Dish* — S2
Hazel, Stephen, *Mindreader* — S3
Heaney, Charles, *The Settlement* — H4
Heaney, Charles, *Genesis 1-20:1* — S4
Hibbard, James, *Greenhouse* — S4
Hickman, Craig, *House/Tree* — H2
Hoffman, Julia, *Studio* — H3
Hoffman, Julia, *Margery Hoffman* — H3
Holmes, Michael, *Red Fire* — S2
Hoppe, William, *Untitled* — 1 State Street East Entrance
Hudetz, Lawrence, *Mountain* — H1
Hudetz, Lawrence, *Eagle Creek, Columbia Gorge* — S3
Huff, Howard, *U.S. 20, Burns, Oregon* — S4
Izquierdo, Manuel, *Moonblades* — 1 State Street West Entrance
Jensen, Jay, *Jasper* — S4
Johanson, George, *Manuel Izquierdo* — 1 State Street West Entrance
Johanson, George, *Cat's Moon Dancer* — H1
Jones, Liza, *Woven Fan* — S2
Joyce, David, *Short People* — H4
Kelly, Charles, *Landscape (Banded)* — H1
Kimball, Louis, *Untitled* — S2
Kimball, Louis, *Untitled* — S3
Kolisch, Marian, *Portrait Of Rachael Griffin* — H2
Kolisch, Marian, *Portrait Of Ansel Adams* — H3
Kowert, Henry (Hank), *Sunrise, Mary Peak* — S2
Kowert, Henry (Hank), *Dry Region* — S2
Krause, La Verne, *Silver Snow Blues* — H4
Krol, Lorraine, *Down Commonwealth* — S4
Lavadour, James, *Flag 2* — S3
Lee, Carolyn, *A Dance Fandango* — S3
Lewis, Steven, *No. 5, Untitled* — H3
Lindburg, Nancy, *Dakotascape I* — S4
Lindburg, Nancy, *Dakotascape II* — S4
Little, Lanny, *Fifty-Six Studebaker* — H2
Lloyd, Susan G., *Water Reflection* — H4
Lommasson, Jim, *Elk Fountain* — H2
Lyman, Marie, *Desert Grasses* — G HR 50
Mahler, Russ, *Venetian Blind* — S2
Massey, William, *Confetti Is Good For The Soul* — S4
Mathers, Michael, *Buckaroo* — H3
Mathers, Michael, *One Ring Circus* — H3
Mathews, Grayson Lane, *Near Christmas Valley, Oregon* — S4
Matoush, Lyle, *A View Through That Man's Land* — S2
McClaran, Robbie, *Barry Lopez* — H2
McCosh, David, *Cascade Study #2* — H3
McLarty, Jack, *Tracking* — H3
McLarty, Jack, *Red Passage* — S4
Miller, Earl, *Stellar* — H3
Miller, Earl, *California Flyer* — S2
Miller, Robert B., *Leigh Clark-Granville* — H3
Monner, Alfred A., *Snowy Evening On Third Avenue* — H4
Morandi, Tom, *November Sprinter* — 1 State Street Entrance
Morris, Hilda, *Five Parts In Search Of A Circle* — H2 Lobby
Ottum, Selina Roberts, *Edith Nelson* — H4
Pander, Henk, *Caryn And Colleen* — S3
Parker, Lucinda, *Sky Horse* — S3

Patrie, Pam, *Untitled* — S4
Paul, Ken, *Remnants Of Landscape* — S4
Peterson, Michael, *Live Oak River* — S3
Phillips, Michael, *Agressive Birth Preparing For Flight* — S2
Pitkin, Orleonok, *Mar* — S3
Pitkin, Orleonok, *Arc Series #6* — S3
Portland, Jack, *This Guy Says...* — H1
Portland, Jack, *No Nookies* — S2
Prochaska, Tom, *Home From The Rain* — H2
Prochaska, Tom, *Sauvie Island II* — H2
Rabel, Kathleen, *Calgary* — S4
Rauschenberg, Christopher, *Untitled* — H4
Raw, Kim C., *Landscape/Hills* — H2
Reed, Cheryl, *Destiny Afternoon* — H3
Ritchie, Bill, *Little Spaceship Crash* — H2
Robinson, Gerald H., *Untitled (Nude)* — H2
Rock, John, *Landscape Composition...* — S2
Rock, John, *The Canopy* — S3
Ross-Paul Laura, *Second Creek* — S2
Ross, Joan Stuart, *Three Magic Wands II* — S3
Rowe, Jeff, *Baker, Oregon* — S3
Runquist, Albert C., *Oregon Landscape* — S1
Runquist, Arthur, *Beach Stumps* — H1
Runquist, Arthur, *Clam Diggers* — S1
Schuler, Melvin, *Round Form* — 1 State Street East Entrance
Sells, Christina, *And Out It Came* — 1 Galleria
Setziol, LeRoy, *Untitled* — S2
Sheehan, Evelyn, *Broken Echo* — H4
Shores, Ken, *Fetish #13-4* — H3
Shull, Jim, *Condon Territory* — H4
Smith, Douglas Campbell, *North Fork Green Water* — H1
Sommer, Ron, *A Falling Of Dreams* — S3
Spilman, Craig, *Metallic Entry* — S3
Steiner, Jerry, *Rocks, South Coast (Pistol River)* — H2
Sumner, Michael, *Piece For Wind* — S3
Sweeden, Virgil, *Barn* — H4
Tilger, Stewart, *Untitled No. 2* — H4
Toedtmeier, Terry, *Fog At Entrance To Sea Cave...* — H1
Toedtmeier, Terry, *Newspaper* — H4
Toedtmeier, Terry, *Faulted Outcrop...* — S3
Trotter, Claire, *Untitled* — S3
Tyler, Phil, *Bringing Up The Team* — S3
Wagner, Bill, *Boat* — S4
West, Bruce, *Untitled* — S1
Weston, Brett, *Driftwood* — H1
Weston, Edward, *Fog, Oregon Coast* — H1
White, Minor, *Portland's SW Front Avenue* — H4
Whitehill-Ward, John, *Offset* — S2
Whitehill-Ward, John, *Obelus* — S2
Widman, Harry, *Rug Invention Series* — S4
Williams, Shedrick, *Vase Still Life* — S1
Wilson, Robert, *Milkcans* — S4
Wolf, Sherrie, *Gathering Dust* — H2
Wyckoff, Christy, *Contrail And Owyhee Summer* — H4
Yang, Janet, *Illiana: Hawaiian Evening* — S3
Zach, Jan, *Drapery Of Memory* — S2 Lobby

The following works were either missing or suggested to be removed from the collection due to poor condition:

Boyden, Frank, *Carp Vase*
Bullock, Wynn, *Boy Fishing*
Cunningham, Imogen, *Rocks, Oregon*
Dailey, Michael, *Beach At Sandy Cove*
Fry-Loftis, Christine, *Big Sur 1-27*
Gifford, Ben, *Boy And Umbrella*
Kowert, Solange, *Untitled*
Mattingly, James, *Lummi Lady*
Quigley, Ed, *Celilo Falls*
Swanson, Betty Jo, *Hootvilla*
Wilson, Don, *Manzanita 2nd Series #1*

Catalog design by Thomas Osborne

Typeset in Scala and Scala Sans
Printed on Opus 30 Dull Text
Printed by Lynx Group, Inc., Salem, Oregon

All photographs by Franklin Miller, except as noted here:

Cover Brophy detail and page 29, NessPace
Fig. 1, page 2 and 29, Nina Olsson
Fig. 2, page 4, Oregon Arts Commission
Fig. 5, page 10, Arlene Schnitzer/Fountain Gallery
Fig. 6, page 10, Al Monner, Arlene Schnitzer/Fountain Gallery
Fig. 7, page 13 and 53, Felicia Phillips
Fig. 10, page 19, Artist/Oregon Arts Commission
Fig. 11 page 20, Artist/Oregon Arts Commission
Fig. 12, page 20, Artist/Oregon Arts Commission
Fig. 13, page 21, Artist/Oregon Arts Commission
Fig. 14, page 22, Artist/Oregon Arts Commission
Fig. 16, page 69, Arlene Schnitzer/Fountain Gallery

All photographic prints, plates pages 24–68, Artist/Oregon Arts Commission, with the exception
of Robert Di Franco, *Sabines Revisited*, Terry Toedtemeier, *Fog at Entrance to Sea Cavern, Cape
Mears* and *Faulted Outcrop*... Franklin Miller.

Cover images:
The Settlement (detail), Charles Heaney (1897–1981);
Humbug Mountain, Oregon Coast (detail), Morley Baer (1916–1995);
The Rising of the Moon 2 (detail), Michael Brophy.
Back cover image: State Street west entrance. Shown: George Johanson. *Manuel Izquierdo*. 1977.
Oil on canvas. Manuel Izquierdo (1925–2009). *Moonblades*. ca. 1976. Welded steel.

Additional Acknowledgments:

The Oregon Arts Commission would also like to acknowledge the following individuals, who
have helped make this project possible: Arts Commission staff Kat Bell, Allison Kerst, Sabina
Samiee; Capitol staff Deborah Bohm, Christine Hartwell, Randy Isaacs and their colleagues;
conservators MPF Conservation, Nina Olsson, Jan Cavanaugh, MLC Objects; fine art handlers
Michael Bland and staff at Art Work Fine Art Services; Framing Resource; advisors Jean Boyer-
Cowling, Fred Tepfer, Roger Hull, Tom Morandi, Sue Taylor; Arlene Schnitzer and Laurie
LaBathe; Debra Royer, Portland Art Museum Crumpacker Family Library; Jane Beebe, PDX
Contemporary Art; designer Thomas Osborne; copy editor Steve Connell.